MAX ERNST

ERNST

Ian Turpin

with notes by Julian Stallabrass

Φ

Phaidon Press Limited
140 Kensington Church Street, London W8 4BN

First published 1979
Second edition, revised and enlarged 1993
© Phaidon Press Limited 1993
Reproductions © 1979 by SPADEM

A CIP catalogue record for this book is available from the British Library

ISBN 0 7148 2866 1

Printed in Hong Kong

Cover illustrations:
Front *Celebes*, 1921. London, Tate Gallery (Plate 7)
Back *Breakfast on the Grass*, 1944. New York, Private Collection (Plate 38)

The author and publishers would like to thank all those museum authorities and private owners who have kindly allowed works in their possession to be reproduced.

The photographs for Plates 9, 20, 26 and 43, and for Fig. 9, were taken by Jacqueline Hyde, Paris.

MAX ERNST

Max Ernst was one of the most complex, as well as one of the most inventive, artists connected with the Dada and Surrealist movements. Associating with those groups because of their attitude of revolt – against the prevailing forms of social organization, politics and philosophy, as well as against the mainstream of contemporary art – Ernst not only made a number of important contributions to the development of Dada and Surrealism, but also elaborated aspects of Dada and Surrealist theory into a comprehensive approach to artistic creation.

The first point to note about Ernst's work is its enormous variety. Standing at the opposite pole to a painter (and fellow-Surrealist) like Magritte, who, with minor exceptions, never deviated from his mature style, Ernst created new techniques and new idioms with astonishing ease. He earned himself the title of 'the complete Surrealist' because of his mastery of both illusionism and abstraction – the dream pictures and automatic paintings which correspond to the two major aspects of Surrealist theory. If this diversity is reminiscent of Picasso, Ernst's art was very different in intention from that of the Cubist painter. Where Picasso claimed to *find* rather than to seek, Ernst's *œuvre* is characterized by an attitude of enquiry. It is this exploitation of many techniques and styles, in the service of a single aim, that provides the essential clue to Ernst's art. While Surrealist theory restricted the role of the Surrealists to that of 'simple recording machines' of the unconscious, Ernst refused to regard art as the mere record either of a dream or of the automatic activity of the hand. Rather, he saw his art as the *process* whereby both dreams and automatism are investigated, as well as the visible result of such investigations. In other words, it was not only a question of exploring the contents of the unconscious mind, but also of initiating a dialogue between the unconscious and the conscious. Many factors entered into this dialogue: unconsciousness seen as a property of mental phenomena on the one hand, and as the repository of universal human concerns (in Jung's sense) on the other; consciousness seen both as the organizing factor which gives ultimate meaning to experience, and as a fallible agent whose dominance produces a one-sided or incomplete picture of reality. Furthermore, Ernst believed that this dialogue between conscious and unconscious should take place on the canvas itself, in the very act of creation. To the extent that he regarded his art as a means of investigation rather than as an end to be savoured for itself, he was not deviating from the defined aims of Surrealism. On the other hand, his attempts to reconcile reason and intuition, intellect and inspiration, through the act of painting, forced him to focus his critical attention on his art in a way not attempted by any other Dada or Surrealist artist.

Ernst was born near Cologne in 1891. His childhood proved rich in incidents, both real and psychological, which later formed the substance of his art. Looming large in his memory was the figure of his

father who, both as a deeply religious man responsible for Ernst's strict Catholic upbringing, and as a Sunday painter, provided a model against which he was to rebel. In spite of this autobiographical element, however, Ernst's art was not simply an attempt to exorcize phantoms from a mind prone to hallucination. A knowledge of the workings of the unconscious, gained through early reading of Freud, enabled Ernst not only to produce images which were consciously symbolic, but also to develop methodologies which would provoke psychic responses in the spectator analogous to those which originally prompted the works of art. To this extent, Ernst's approach differed from that of those Surrealists who stopped short at a simple acceptance of their dreams. As though foreseeing Freud's refusal to contribute to a Surrealist anthology of dreams on the grounds that such a collection would be meaningless without knowledge of the dreamer and the context of the dream, Ernst packed his pictures with references and allusions of a psychological, theological, scientific, historical, and even art-historical nature. Such an art is essentially literary. At the same time, Ernst's significance rests on the fact that he did not rely on illustration, but recreated his experiences through analogous artistic processes. This accounts for the relatedness of method, style and subject-matter across the wide spectrum of his *oeuvre*.

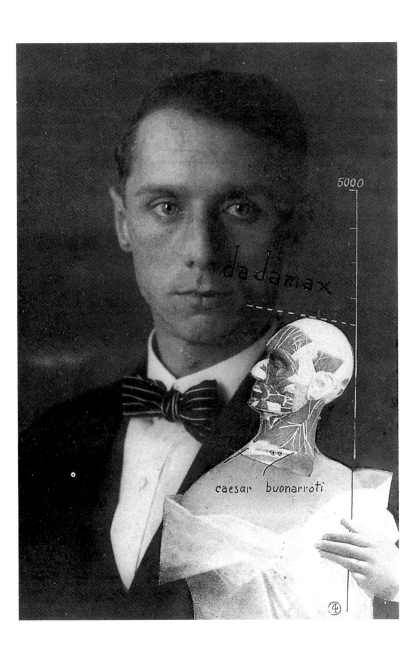

Fig. 1
The Punching Ball or
The Immortality of
Buonarotti
1920. Photo-collage, 176 x
115 cm. Chicago, Private
Collection

Ernst's beginnings as an artist were marked by wide-ranging experiments in the field of modern painting. Chief amongst the early influences was Van Gogh, whose work was known to him well before the Cologne Sonderbund exhibition of modern art in 1912, which made Ernst commit himself to a career as a painter. This influence can be seen in a number of paintings dating from as early as 1909, which exhibit strong colour and vigorous brushwork. In 1911, just over a year after he entered Bonn University, where, largely to please his father, he had enrolled to read philosophy and psychology, Ernst met the Expressionist painter August Macke. Macke introduced Ernst to many other painters, including fellow-members of the 'Blue Rider' group and the French painter Robert Delaunay. Delaunay's 'Orphism' (an optical variant on Cubism), with its attendant colour symbolism, was an important influence on many German painters, including those of the Blue Rider. Ernst's response to this influence can be seen in *Flowers and Fish* (Plate 1), where it is filtered through the animism of Franz Marc. He painted the picture while serving as an artillery engineer with the German army during the First World War.

The influence of Expressionism on Ernst did not survive the First World War. As the leading avant-garde movement in Germany at the time, it was a prime target for the Dadaists' attack on Western culture. Yet Ernst was not drawn to Dada simply as a reaction against Expressionism, or for purely political reasons. The impetus came from interests which he had pursued during the pre-war period, and which began to play an important part in his art as the bankruptcy of Western civilization, and of the art it had spawned, became apparent to him. As a student of psychology Ernst had visited a local mental hospital, where paintings produced by the inmates had caught his imagination. The knowledge of psychology and of psychoanalytic theory that he gained during this period (particularly from reading Freud) enabled him to develop an understanding of the artistic products of the mentally ill, of children, and of primitive cultures, whose art was prized by the avant-garde for its formal characteristics.

The Dada revolt took a number of forms, from the overtly political to a faith in a new art as the only possible saviour of mankind. Although it was this latter aspect that attracted Ernst on his discharge from the army in 1917, his art, as it developed, was not informed by the simple optimism of Arp. Neither, however, did it bear much relation to the stringent iconoclasm of Dadaists like Marcel Duchamp.

Ernst's contribution to the Dada attack on both modernist art and accepted values in general was *collage* (Plates 2-5). First developed by the Cubist painters in 1912, collage had assumed important 'anti-art' connotations for the Dadaists, who made various uses of it, from the overtly political *photomontage* in Berlin to Schwitters's *Merz* collages in Hanover (Fig. 2). Ernst lay somewhere between these two extremes. He regarded collage initially as a method of exploring the possibilities of representation outside the limitations of Cubist formalism. His concerns were not with abstract form, but with the strange juxtapositions which he was able to obtain by collaging parts of photographs and engravings. Ernst's discovery of this aspect of collage was prompted by the absurd combinations of objects in some scientific catalogues. These combinations, as he later described them, 'provoked a sudden intensification of the visionary faculties in me and brought forth an illusive succession of contradictory images . . . piling up on each other with the persistence and rapidity which are peculiar to love memories and visions of half sleep'. Ernst found that he could enhance the poetic effect of these juxtapositions by adding an odd line, an area of colour, or 'a landscape foreign to the represented objects'. These col-

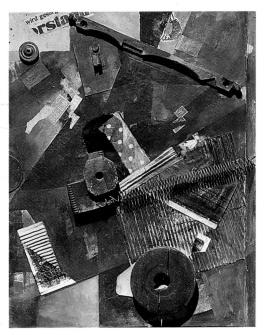

Fig. 2
Kurt Schwitters
Dislocated Forces
1920. Collage,
105.5 x 86.7 cm. Bern,
Kunstmuseum

7

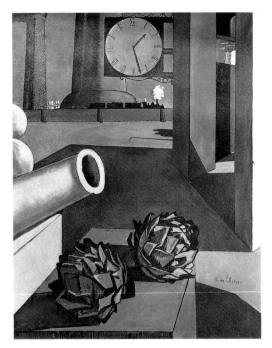

Fig. 3
Giorgio de Chirico
The Philosopher's
Conquest
1914. Oil on canvas,
126 x 98.5 cm.
Courtesy of The Art
Institute of Chicago,
Collection Joseph
Winterbotham Co.

Fig. 4
Lithograph from 'Fiat
Modes, Pereat Ars'
1919. 43.7 x 31.9 cm.

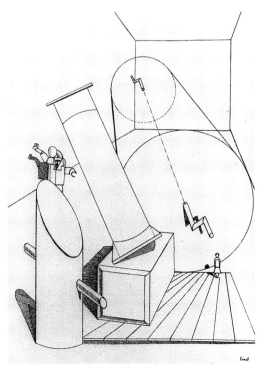

lages were not only or essentially anti-art gestures. Their dreamlike appearance also suggested the possibility of attacking contemporary values in general, particularly the reliance on reason. In this attack, Ernst posited the dream as the point at which the contents of the unconscious mind most easily enter consciousness. Ernst came to describe the additions he made to his collages as changing them into images which 'transformed into revealing dreams my most secret desires'.

Ernst's use of the dream as a matrix for the combination of unrelated objects had a number of precedents, the most important of which were the 'metaphysical' paintings of the Italian, Giorgio de Chirico, which Ernst first encountered through illustrations in 1919. These paintings by de Chirico exhibit, in varying combinations, conflicting perspectives, contradictory flat and modelled forms, strange lighting, and odd juxtapositions of unrelated objects, which combine to produce a consistent and convincing dreamlike effect (Fig. 3). Although it was not until 1921 that Ernst fully accepted de Chirico's influence, the Italian painter did reveal to him the possibilities of a 'culture of systematic displacement and its effects', the immediate impact of which can be seen in a series of eight lithographs dated 1919, which Ernst entitled *Fiat Modes, Pereat Ars* (Fig. 4).

In 1920, Ernst was joined in Cologne by Hans Arp, whom he had known for a brief period before the outbreak of war in 1914, and by the socialist activist Alfred Grünwald, alias Johannes Baargeld. Together they formed the Cologne Dada group, which over a period of little more than a year published a number of short-lived reviews and held two exhibitions. Cologne Dada was marked by the artistic bias of its activities. Although both exhibitions were more in the nature of Dada provocations than traditional art shows (at one, visitors were invited to destroy the exhibits with an axe, which was provided for the purpose), Ernst was at the same time working on a series of collages, which he showed in May 1921 at the Au Sans Pareil Gallery in Paris under the title 'Beyond Painting'. This exhibition, which had been organized by André Breton, the future leader of the Surrealist group, is evidence of the close contact with Paris which was a distinguishing characteristic of Dada in Cologne. The collages which Ernst exhibited (Plates 3-5) reveal a variety of arrangements, from the simple modification of a single image, to the creation of composite creatures from parts of objects drawn from similar sources. These objects are sometimes inconsistently modelled; sometimes they are placed in a space which contradicts either their modelling or their perspectival arrangement; sometimes they are thrust towards their picture-plane in violent foreshortening, which increases their psychological impact. As well as recalling de Chirico, these collages also reveal the influence of the mechanistic imagery of Ernst's fellow-Dadaists, Duchamp and Picabia. The close link between the Dada poets and painters is reflected in the importance which Ernst attached to the titles of his collages. Clearly composed on the same principle as the images, he designated the titles themselves 'verbal collages'. Frequently long and poetically written, often in several languages, on the works themselves, their distortion of commonsense reality parallels that of the images, to which they bear a reciprocal relation as both inspiration and amplification. This practice coincided with his enthusiastic reading of Novalis and Hölderlin. Ernst's experiments with word-image combinations – which were to influence the development of *peinture-poésie*, which the Surrealists opposed to the pure abstraction of the avant-garde – came to a head in a series of *Picture-Poems* dating from 1923-4 (Plate 15). Here the words not only react with the image,

they form part of the very structure of the composition. The rapturous reception which Ernst's collages received when they were exhibited in Paris in 1921 presaged the contribution he was to make not only in helping Breton define Surrealism in theory, but also in providing a model for those painters who were to respond to Breton's call for dream description. During the period between his Paris exhibition and Breton's first *Manifesto of Surrealism* (1924), the so-called '*époque floue*', Ernst returned to canvas and painted a series of works in which he combined his collage preoccupations with devices derived from de Chirico, though interpreted in more personal terms (Plates 7-11 and 14).

In *The Teetering Woman* (Plate 11), de Chirico's stage setting, here featuring classical pillars, supports a barely modelled, collage-like machine image. Other paintings in the series exhibit such collage-derived features as hybrid creatures and conflicting perspectives, but with a greater emphasis on confrontations between unrelated objects within an irrational context. Both *Celebes* (Plate 7) and *Woman, Old Man and Flower* (Plate 10) use heterogeneous creatures as the main protagonists. In the former painting an imposing figure, based on Sudanese corn bins and resembling a vacuum cleaner, confronts a headless, gloved, classical nude and a strange pillar reminiscent of the occupants of *The Hat Makes the Man* (Plate 4). The body of the old man in the latter picture consists of a broken flowerpot, while the woman's head is a fan, and her body pierced metal sheeting. In *Oedipus Rex* (Plate 9) the modelling of the pierced hand, which emerges through a window clutching a walnut, contradicts that of the birds' heads, which appear curiously flat in comparison. The contradictory viewpoints from which the birds' heads and the enclosing fence are seen augment the effect of the perspectives in the buildings in creating an indecipherable space. In a number of these paintings, objects float through the sky, to

Fig. 5
Le rendezvous
des amis
1922. Oil on canvas, 100 x
195 cm. Cologne, Wallraf-
Richartz Museum

varying effect. In *Oedipus Rex* the unexceptional nature of the hot air balloon contrasts with the strange inhabitants of the earth below. In *Celebes* the sky is confused with the sea to the extent of supporting a number of fish. Despite the fact that the subject-matter of these 1921-4 paintings frequently presupposes a knowledge of Freudian theory, the actual psychological element is largely personal. This is seen most clearly by comparing *Pietà, or Revolution by Night* (Plate 8) with *At the First Clear Word* (Plate 13). In the latter picture the sexual theme is made explicit in the identification of the outstretched fingers of the hand with the lower female torso. In the former, the paternal figure supporting the barely sketched younger one is undoubtedly Ernst's father, who painted many religious pictures, in at least one of which the face of the infant Jesus is modelled on that of the young Max Ernst. Childhood experience, this time of terror, appears in *Two Children are Threatened by a Nightingale* (Plate 14). This work is remarkable for its extension of the use made in the collages of lithographed and photographed images as a ready-made reality to the incorporation of wooden constructions.

Here the psychic dislocation does not result so much from a combination of style and content as from a clash between the two. A man runs (or perhaps falls, a feeling common in dreams) across the roof of a wooden house towards a real alarm bell, while a girl pursues a nightingale (the shyest of birds) which has just felled her sister, against a background in vertiginous perspective, which features a triumphal arch at the far end and a wooden gate swinging on real hinges at the near.

Although *Men Shall Know Nothing of This* (Plate 12) depends for its effect, like the other paintings in the series, on the shock of recognition as we piece together the various elements, it also contains a significant illustrative aspect which makes reference to many sources: scientific, psychoanalytical, astrological, and occult. On the back of the painting Ernst provided an interpretation in the form of a poem, which ends: 'The moon goes very quickly through its phases and eclipses. The picture is odd in its symmetry. The two sexes balance each other there.'

In 1922, the year which saw Breton's first tentative definition of Surrealism as 'a certain psychic automatism that corresponds rather closely to the state of dreaming', Ernst entered illegally into France, to stay at the home of the poet Paul Eluard. In 1924 he accompanied Eluard and his wife on a trip to the Far East. After a few months he returned to Paris, to a group that was avidly discussing Breton's 'First Manifesto', which had been published during Ernst's absence. Breton's document is remarkable as a codification of ideas which had been present in Dada, particularly concerning automatism and chance, and a justification for their extension based on Freudian psychology.

Ernst's reaction was to change both the basis and the style of his painting, and he did so under the impetus of a discovery which he related to Breton's automatism, but which derived in the first place from his own childhood memories. This discovery was *frottage*. As Ernst described it, the deeply indented grooves of a wooden floor which he was examining one day reminded him of a childhood memory of false mahogany panelling, which had, at the time, brought to mind associations of organic forms (Fig. 24). Placing paper randomly over the floorboards and rubbing with a pencil on the back, Ernst was surprised by the way in which, as he put it, 'the drawings thus obtained steadily lose . . . the character of the material studied – wood – and assume the aspect of unbelievably clear images of a kind able to reveal the first cause of the obsession.'

Fig. 6
Mer et Soleil
1925. Edinburgh,
Scottish National
Gallery of Modern Art

Thirty-four frottages were published in Paris in 1926, under the title *Histoire naturelle*. These added to the dreamlike combination of objects in the Dada collages a similar confrontation between textures. These textures were combined into rubbings which give the appearance of having emerged from the subconscious bearing the imprint of some subliminal obsession. Some of these frottages remain relatively close to their sources. In one, a few floorboards take on the impression of a wooden fence. In others, such as the one illustrated here, the sources are all but indecipherable. These frottages, with their mysterious figures and subtle tonality, are amongst the most exquisite works of graphic art produced this century. Notwithstanding this, Ernst stressed the links between frottage and automatism. Belying the adroitness that undoubtedly went into their production, he wrote that the role of the artist had been reduced to that of 'spectator . . . at the birth of his work', which was thereby put beyond those controls normally associated with art: reason, taste, morality.

The period immediately following the discovery of frottage was a very productive one for Ernst. Under the influence of fellow-Surrealist painter Miró, Ernst adapted the process of frottage to oil painting (Fig. 6). The new process was known as *grattage*. It consisted of scraping wet paint from unstretched canvas which was draped over objects and

11

surfaces. The resulting textures were partially elaborated with a brush amongst the several layers of the painted surface which were revealed. The adaptation of frottage to oil-paint is well illustrated in *Two Sisters* (Plate 18), where Ernst not only stuck fairly close to the sources of the textures, and even imitated with black paint the effect of pencil frottage, but also echoed the subtle tonality of the *Histoire naturelle* series in pastel colouring.

In *To the 100,000 Doves* (Plate 18) the birds' heads, brushed in amongst the dense texturing, suggest a vast flock. Here, the shallow space of the *Histoire naturelle* frottages is completely flattened out. The figurative elements lack modelling, and emerge from the background to form a grid reminiscent of those resulting from the disintegration of the visible world in Analytic Cubism.

The *Forest* series of pictures refer directly to Ernst's childhood, as well as to the work of earlier German painters. Ernst's early feelings towards forests were equivocal. They were delightful and oppressive places at the same time, offering both the freedom of the open air and, in their depths, an atmosphere of entombment. These feelings were expressed with powerful simplicity in *The Great Forest* (Plate 25). The forest, which in the series as a whole can be read either as trees or as rocky crags, has no depth to it; it is placed close to the picture-plane and takes on the appearance of a stage-flat. Behind it is a brushed-in illusionistic sky, containing a sun- or moon-like ring which emits an eerie light. The combination of illusionism and artifice creates an unsettling scene which leads us to question how much of what we see is really there, outside us, and how much we create for ourselves. Ernst's approach to the tradition of forest painting in Germany reflected the influence of the Romantics' 'emotion in the face of nature'. Ernst himself referred to Caspar David Friedrich's exhortation to painters to close their physical eyes in order to see with the 'spiritual eye'. Ernst's spiritual vision interpreted the forest in terms of both personal fantasy and the universal collective unconscious. Some of the forests contain trapped birds, which increases the sense of foreboding and recalls both the darker side of German fairytales (which again Ernst remembered from his childhood) and the extravagant horror of eighteenth-century Gothic novels, which the Surrealists so prized.

The textures of the *Horde* series (Plate 24) were created by using different thicknesses of twine, from whose coils emerge threatening anthropomorphs. As in the *Forest* series, the background is brushed in, though here it plays a more purely plastic role, locking the horde into the picture-plane. The fact that the group fills the picture-space renders *The Horde* less subtly menacing and more purely aggressive than the *Forests*. Whereas the latter are recognizable dream landscapes, *The Horde* works as a metaphor for the darker side of the unconscious.

A variant on the rope grattage process was responsible for *One Night of Love* (Plate 27), a similarly powerful but richer and more complex work than *The Horde*. Ernst dropped different thicknesses of paint-soaked twine onto the canvas, and from the linear pattern thus formed he developed a horned male creature, a female figure, and various animal forms. The male, his dark colouring and bared teeth combining into a threatening presence, appears to be moulding the female and animal forms, which, with the exception of the bird in the male's hands, are the same colour as the surface on which they rest, and rendered insubstantial in comparison with the male. The generalized violence of *The Horde* is here made more specific, and may refer, given Ernst's identification with birds (see below), to the moment of his own

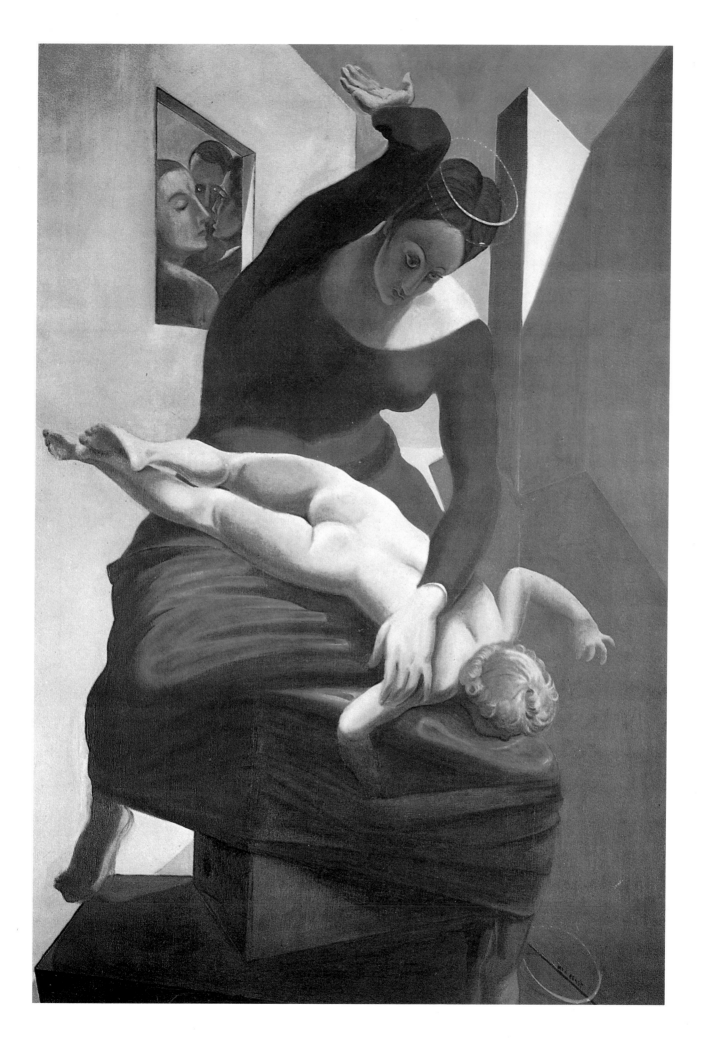

Fig. 8
Pablo Picasso
Figures by the Sea
1931. Oil on canvas,
130 x 195 cm.
Private Collection

Fig. 9
Yachting
(from a collage
novel entitled *La
Femme 100 têtes*)
1929. Collage, 8 x 10.8 cm.
Paris, Private Collection

conception. The anatomical distortions, resulting partly from Ernst's painting method, also derive from Miró, Picasso's monumental groups of the 1920s, and the conflicting perspectives of de Chirico. This reference to the work of other painters also provides a clue to the sand-textured surface of *One Night of Love*, which contrasts with the dryness of many of Ernst's earlier anti-art paintings.

On a much simpler and more purely decorative level, Ernst painted a series of works around 1927 known as the *Snow Flowers* (Plate 22). Here, forms reminiscent of flowers and shells, created by the grattage process, are set off against flatly painted backgrounds, some of which, as here, are given a spatial dimension through the use of different coloured areas.

The bird that appears caged in *Snow Flowers* was a symbol of which Ernst had made ample use in his work from an early stage (see Plates 5, 9, 14, 16, 25, 27 and Fig. 24). In the mid-1920s this interest came to the fore, and emerged as an obsession with one creature in particular: 'Loplop, the Superior of the Birds'. This obsession derived from a childhood incident in which the death of a pet cockatoo coincided with the birth of a sister. As Ernst described it, in the third person: 'In his imagination he connected both events and charged the baby with the extinction of the bird's life. . . A dangerous confusion between birds and humans became encrusted in his mind.' There were undoubtedly other sources for Loplop; for example, birds play an important role in German mythology. There are also references to birds in the writings of Freud. One such credits Leonardo da Vinci with a vulture fixation, based on the bird's disguised appearance in the

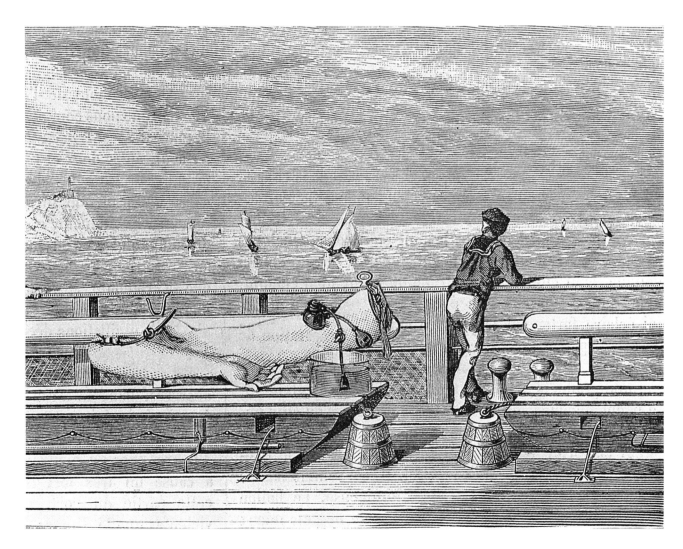

painting *The Virgin and Child with St Anne* (Fig. 27). In the earlier paintings dealing with this obsession the birds are often trapped, for example in a forest (Plate 25), or in a cage (Plate 22). In 1927, however, Loplop emerged victorious, in a painting which prefigured Ernst's return, in the 1930s, to a more literal realism. *Monument to the Birds* (Plate 20), a reference to the Renaissance tradition of Assumption pictures, is painted in the dry manner which characterizes the works of the early 1920s inspired by de Chirico (Plates 7-11 and 14). Ernst rarely touched on religious themes. As a piece of Dada provocation he had painted a sacrilegious work entitled *The Virgin Mary Beating the Infant Jesus* (1923; Fig. 7), and in 1931 Loplop emerged as *Chaste Joseph*, a reference to Ernst Senior, the painter of religious themes and father of a large family. The last year of the decade saw a series of paintings generically entitled *On the Inside of Sight* (Plate 21), in which bird-forms inhabit rounded or egg shapes in a confusion between inner and outer, unconscious and conscious. Loplop also made numerous appearances in the guise of a master of ceremonies. In a number of oil paintings he is presenting another picture, which forms his body. These pictures within pictures are always variations on works by Ernst. Elsewhere he takes on a more anthropomorphic appearance. In a low relief, *Loplop Presents a Young Girl*, the bird holds a frame containing a number of collage objects, including the girl's profile.

During the 1930s Ernst approached collage from two angles. He took as his subject the complex interplay between various approaches to representation (Plates 23 and 29) and underlying assumptions both about the nature of reality and about our perception of it (Fig. 8). The antagonism between unconscious and conscious response, which forms the basis of the mystery of *Loplop Presents* (Plate 29), exists as a conflict between two different styles: the flat, decorative qualities of the marbled paper and ink-blotter, and the illusionism of the art-manual drawings, all of which are arranged in an almost Cubist manner. Loplop, in the form of an outline drawing, arbitrates between the two styles: in effect, he attempts to reintegrate the human personality.

Ernst's mastery of collage was put to its most effective use in the 1930s in another of his discoveries, the collage novel (Figs. 9-12). These 'novels' consist of a series of collages based on nineteenth-century book illustrations, which Ernst cut up and reassembled. The relationship between the collage novels and those whose illustrations they use is a complex one. Not only did the original novels provide Ernst with subject-matter through their illustrations, which served as his source material; they also represented an attitude whose satirization is Ernst's real theme. Taking as his point of departure Breton's attack on the nineteenth-century novel as an example of the despised 'realistic attitude', with its underpinning of reason and logic, Ernst presents us with unusual juxtapositions which invert the original meaning of their source. Through small changes which bring about confrontations between objects and contexts, Ernst turned what had been simple illustrations into explicit condemnations of nineteenth-century society. His main themes were religious bigotry and sexual repression, which, after Freud, were held responsible for all manner of ills, both psychological and physical. Furthermore, the very form of the collage novels involved an implicit criticism of the society which found expression in the novel form, since they lack a story which unfolds towards a dénouement, and consist instead of a series of episodes only loosely related and having no ending.

The first of these collage novels was published in 1929. Its title, *La Femme 100 têtes*, (*The Hundred Headed Woman*) is a pun on the French

Fig. 10
Culture physique, or
La mort qu'il vous
plaire
(from a collage novel
entitled *La Femme 100 têtes*)
1929. Collage

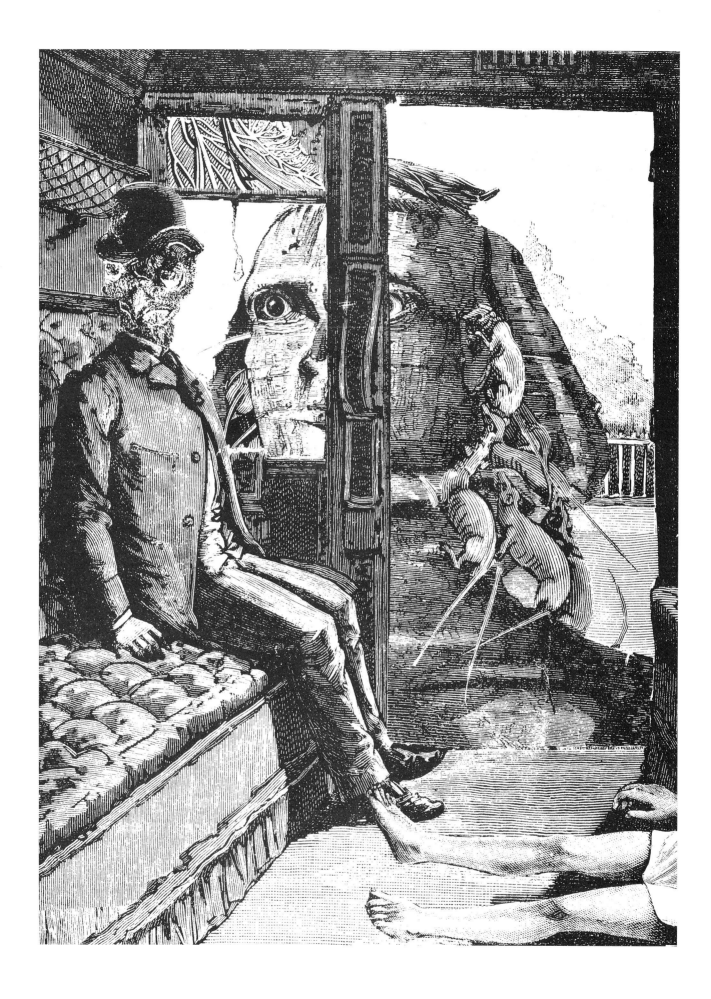

words *cent* (a hundred) and *sans* (without), so that the woman is simultaneously headless and blessed with more than her fair share of heads. Each collage has a caption, which plays a role similar to that of the titles of the Dada collages, often exhibiting a strong element of Surrealist 'black humour'. The brief title *Yachting* which accompanies the collage illustrated (Fig. 9) evokes perfectly the idyllic situation which will be shattered irrevocably when the sailor turns round to be confronted by the huge dismembered limbs lying on the bench beside him.

In 1934 Ernst published *Une Semaine de bonté* which was subtitled *Les Sept éléments capitaux*. Appearing as five separate booklets, *Une Semaine de bonté* gives us one 'deadly element', and an example of that element, for each day of the week. Fig. 11 comes from 'Wednesday's Book'. Its element is 'blood' (of the traditional four elements, Ernst retained only fire and water) and its example is 'Oedipus', who broke laws regarding sexual relations with blood relatives, and with whom the Sphinx of the illustration is associated. Fig. 12 is from 'Sunday's Book', its element is mud, its example a lion. The action of *Une Semaine de bonté* is much more dramatic, not to say theatrical, than that of *La Femme 100 têtes*. This possibly reflects the deepening gloom of the European political situation as much as the crisis which occurred in Ernst's art (as it did in much Surrealist as well as avant-garde painting) in the 1930s. The characters of *Une Semaine de bonté* are in general both closer to the picture-plane and larger in relation to the surrounding space than those of the earlier novel. There is consequently a feeling not so much of a conflict between conscious and unconscious, as of a direct assault by the latter on the former.

The 1930s saw a significant change both in Ernst's attitude towards Surrealism and in his approach to artistic problems. Surrealist painting of the period was dominated by the illusionism of Dali, Magritte and Tanguy, while the abstractionists Masson and Miró, as well as Ernst himself, suffered a failing inventiveness. The deepening gloom apparent in much Surrealist painting of the 1930s mirrored the worsening political and economic situation in Europe, although (reflecting Breton's refusal to commit Surrealism as a propaganda machine for the left) the Surrealist painters did not comment directly upon it. The only exception to this was Ernst, who, through the use of allegory and symbol, focused his attention on those darker aspects of man's personality which were coming to the fore. This new approach consisted of a novel emphasis on what Ernst regarded as the failure of reconciliation between conscious and unconscious, reason and intuition, and the practical results of this failure.

During the 1930s Ernst relied on styles and methods he had invented in the 1920s. He alternated between flat patterning derived from his frottage and grattage works (Plates 28 and 31) and sculptural illusion which harked back to the period of the early 1920s inspired by de Chirico (Plates 30 and 32-4). At the same time, his work possessed a confidence which belied both his financial situation, which was never very stable, and his position as a member of the Surrealist group, which deteriorated after his temporary expulsion, along with Miró, in 1926, for designing sets for a Diaghilev ballet.

In the *Garden Aeroplane-Trap* series (Plate 30) poisonous plants lurk within a series of walled areas to trap and destroy passing planes. Ernst owned a nineteenth-century manual of bird-trapping methods, and in turning from Loplop to man-made flyers he was making a comment on the decreasing political and intellectual liberty in Europe at the time. The cool colour and dry precision of the brushwork accentuate rather than diminish the horror of the scene. The conventional perspective

Fig. 11
Oedipus
(from a collage novel entitled *Une Semaine de bonté*)
1934. Collage,
28 x 20.5 cm.

Fig. 12
The Lion of Bellefort
(from a collage novel
entitled *Une Semaine
de bonté*)
1934. Collage,
28 x 20.5 cm.

of the *Garden Aeroplane-Traps* attests to the influence of the illusionistic Surrealists on Ernst. There is, however, nothing in their work quite so coolly fantastic as these natural machines of destruction.

The ramparts of the *Garden Aeroplane-Traps* developed into complete fortresses in a series of paintings of *Whole Cities* (Plate 31). These are basically variations on the *Forest* pictures of the later 1920s (Plate 25). Similarly created through the grattage process, they consist either of flat patterning close up to the picture-plane, or an illusion of shallow depth, as in the one illustrated here. A flat disc sun casts a menacing light over most of the cities in the series, and in some cases illuminates a carnivorous jungle in the foreground, whose threatening presence is made more sinister because its illusionistic style contrasts with the flatness of the city itself. The *Whole City* series can be seen as a metaphor for the destruction of man's rational constructions by the dark forces of the unconscious mind, when those forces remain repressed.

The spiky vegetation which creeps menacingly upwards in *The Whole City* developed into a lush, though no less dangerous, forest in a series painted in the years 1936-8, of which *Joie de Vivre* (Plate 32) is an example. In this series, the contrast between the luxuriance of the vegetation and Ernst's dry painting manner offers a clue to the picture's theme. The vegetation does not represent the richness of life, but its dangers, for it conceals predatory animals – and is even confused with them at points. Outwardly reminiscent of the mysterious but always friendly jungles of the 'Douanier' Rousseau, whose work was greatly admired by the Surrealists, Ernst's jungles spawn monsters and exude an air of entrapment. His rejection of the Surrealist 'resolution' of dream and reality is here extended to the Romantic notion of a harmony between man and nature. The forest, which spelt freedom as well as confinement to the young Ernst, has come to offer only death.

The delight in conjuring up monsters with which to mock man's reliance on his rational powers, which *Joie de Vivre* evinces, became more explicit in a number of paintings which Ernst made towards the end of the 1930s, and of which *The Angel of Hearth and Home* (Plate 33) and *The Robing of the Bride* (Plate 34) are good examples. Both paintings possess a dreamlike clarity; yet where in earlier paintings the combination of rationally unrelated objects was aimed at providing that 'spark' which would illuminate the depths of the unconscious, the dream here has produced monsters whose threat is as much physical as psychic. The former work was painted after the defeat of the Republicans in the Spanish Civil War, and represents a rare reference by Ernst to a specific political event. For a brief period the painting bore the ironic title *Triumph of Surrealism*, as though Ernst had despaired even of the movement's aims. The year following its completion saw Ernst's final break with Surrealism, over Breton's rupture with Paul Eluard, who had been Ernst's lifelong friend. Although Ernst had put his name to a number of Surrealist documents, he had always maintained a certain distance from the group, which he had always regarded as a prerequisite of creative freedom.

Perhaps the finest work which Ernst produced during the 1930s was a series featuring images of a simultaneously psychological and sexual nature. *Blind Swimmer* (Plate 28) represents a culmination of Ernst's interest in the relationship between sexual and psychological repression. The seed forcing its way along the channels, which derive formally from his earlier wood frottages, represents at one and the same time the male seed, the repressed contents of the unconscious, and the creative impulse, all seeking an outlet.

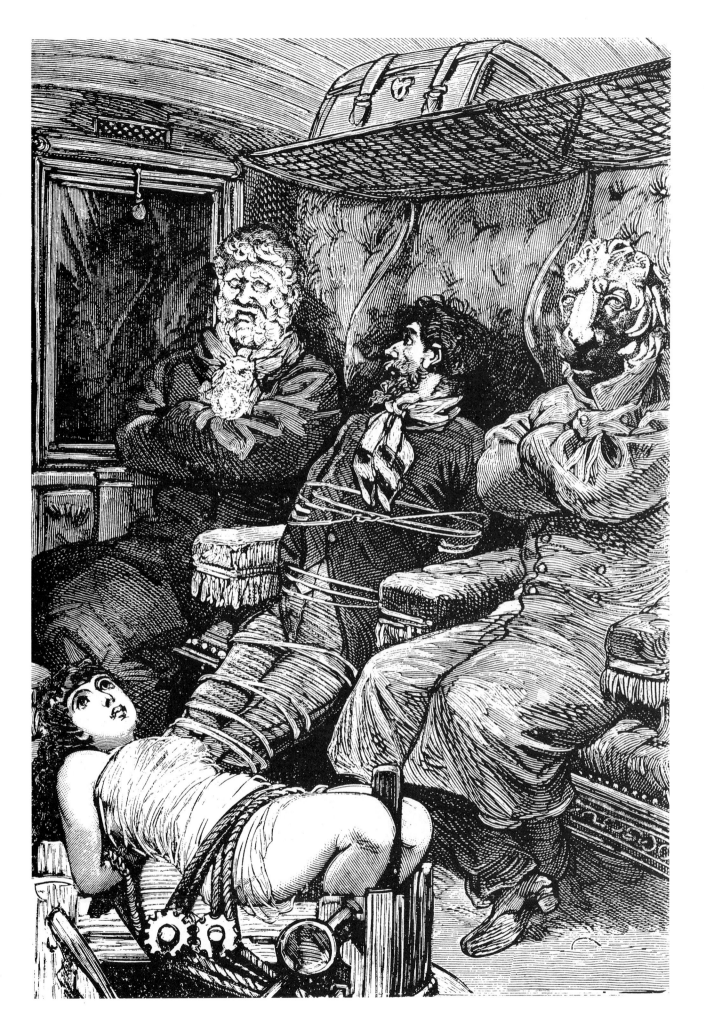

Fig. 13
Hans Bellmer
The Doll
c.1937-8. Photograph
tinted with coloured ink,
53 x 53 cm. London,
Tate Gallery

On the outbreak of war in 1939 Ernst was interned by the French authorities as an enemy alien. During this internment he met fellow-Surrealist Hans Bellmer (Fig. 13), and together they experimented with a technique of automatic painting which had first been used by Oscar Dominguez in 1935. The 'decalcomania' technique, which consists of sandwiching ink between layers of paper, had been received with enthusiasm by the Surrealist group, particularly the poets. With little skill they were able to achieve interesting results susceptible to multiple interpretation in the manner of Rorschach inkblots. It was left to Ernst, however, to apply the decalcomania technique to oil-paint and canvas (Plates 35-7 and 39). In so doing he developed the iconographic possibilities of his earlier jungle pictures and produced some of the most penetrating comments on contemporary society in the whole of modern art.

As with the earlier grattage process (Plates 16-18, 22, 24, 25 and 27), Ernst worked up suggestions provided by the initial automatic sandwiching, using a brush, and finally painted in a background. However, the decalcomania paintings differ from the earlier examples of developed automatism in a number of important respects. Firstly, the working-up in, for example, *Napoleon in the Wilderness* (Plate 35), consists of the addition of conventionally illusionistic areas, which contrast with the original paintwork. This juxtaposition of different styles and methods creates an atmosphere of disjointedness, as in dreams, and relates the painting to the collage process of odd combinations. In other paintings of the series (for example, Plate 36) the clash is less acute because the decalcomania areas take on a distinctly *trompe-l'oeil* character, reminiscent of the work of Gustave Moreau. These paintings reveal Ernst's ability to conjure the richness of reality from the very stuff of the paint itself. Secondly, the implications of the relationship between foreground and background differ between the two methods. In the grattage works (see Plates 25 and 31) the contrast between the flat patterning of the main subject and the view back into infinite space suggests the distance between two realities: Freud's 'pleasure' and 'reality' principles. This is not the case in the decalcomania pictures, where the *trompe-l'oeil* nature of the automatic passages relates them to the background, which acts as an impassive backdrop to the foreground action.

The most imposing painting of the series is undoubtedly *Europe After the Rains II* (Plate 36), which Ernst began in France and completed in America after a long and perilous flight. Here the decalcomania technique has produced a spongy, rotting landscape redolent of decay. As an indictment of war it works much more effectively than the earlier *Angel of Hearth and Home* (Plate 33). Animal, vegetable and mineral forms simultaneously emerge from and sink back into the substance of the paint.

The Temptation of St Antony (Plate 39) exhibits more brushwork than other paintings in the series, and harks back more directly to the jungle pictures of the 1930s (Plate 32). In the period after about 1935, Ernst turned increasingly to the traditional Germanic interest in forests and in monsters to express his feelings about the political developments which were symptomatic of the psychological development of modern European man. Both in its confusion of plant and animal forms and in its dark pessimism, *The Temptation of St Antony* is reminiscent of the visions of such German painters as Schongauer and Grünewald.

In other pictures of the period Ernst restated some of his earlier concerns, for example *peinture-poésie* (Plate 38), and a more orthodox Surrealist dream atmosphere. In another major work dating from

Ernst's stay in America, *Vox Angelica* (Plate 37), he recapitulated in a systematic manner the various styles and techniques which he had incorporated in his art over the previous quarter-century. This painting is divided into a series of rectangular areas by framelike horizontals and verticals. It features, amongst other things, passages of decalcomania, frottage, grattage, and 1930s forestation, as well as imprisoned birds and mathematical instruments. Ernst wrote of the painting that it was an 'autobiographical account, in episodes of dream and reality, of his peregrinations from one country to another'. His actual physical moves are represented by the Eiffel Tower and the Empire State Building.

An area towards the top right-hand corner of *Vox Angelica* contains a passage in which Ernst referred to the last technical innovation of his career. 'Oscillation', as this method was known, was an automatic technique in which liquid paint was dripped from a small hole in the bottom of a tin can, which was swung randomly from the end of a piece of string over a canvas laid horizontally on the floor. It was, however, used for only a few paintings (Plate 42), which suggests that Ernst found it insufficiently flexible for his expressive needs.

The increasing importance of sculptural illusion in Surrealist art during the 1930s was reflected in a corresponding interest shown by the group in actual objects. After Breton's call for the manufacture of irrational objects from dreams, the Surrealist object took on an importance as the concrete materialization of secret desires.

This move was reflected in Ernst's art by an interest in sculpture, which emerged in 1934. Before that time, his investigations into the third dimension had been few. From his Dada days little remains but

Fig. 14
The Fruit of a
Long Experience
1919. Painted wood relief,
45.7 x 38 cm. Geneva,
Private Collection

Fig. 15
Head-Bird
1934-5. Bronze, 53 cm
high. Private Collection

a wood relief entitled *Fruit of a Long Experience* (Fig. 14). This work, which is close to the collage reliefs of fellow-Dadaist Kurt Schwitters (Fig. 2), was more a Dada protest against the traditional materials of paint and canvas than a real attempt to move out of two dimensions. Ernst's interest in sculpture was stimulated by a visit he made to Switzerland in the summer of 1934, where he stayed with the sculptor Giacometti. Using Giacometti's tools, he modelled in low relief some stones which the two found in a local riverbed. On his return to Paris he began working in plaster. He combined casts of everyday objects, on the collage principle, to create strange creatures whose humour contrasts with the darker aspects of his contemporary paintings. Pieces such as *Head-Bird* (Fig. 15) reflect an awareness of primitive art more than of modern sculpture. Indeed, Ernst's ignorance of the work of contemporary sculptors seems to have lent his efforts a freshness which was conspicuously lacking in theirs during the 1930s. Ernst let sculpture drop after 1935 and did not take it up again until 1944, when he was living on Long Island. Here he began a series on the theme of chess. The most imposing of these, *The King Playing with the Queen* (Plate 41), derives both from Giacometti's tabletop sculptures of the early 1930s and from certain of Ernst's own paintings, particularly *One Night of Love* (Plate 27).

In 1946 Ernst moved to Arizona. His experience of the landscape and of the light there proved decisive in determining the direction his art took from then on until his death. The *Coloradeau of Medusa* (Plate 45), which was inspired by a visit to the Colorado River, has the appearance of rock strata seen through a heat haze. The interpenetrating layers of colour suggest a mindscape in which the relationship between conscious and unconscious levels has become confused.

On his return to Europe in 1953 Ernst settled in Paris, but made an almost immediate visit to Cologne. This trip resulted in *Old Father*

Fig. 16
The Preparation
of Glue from Bones
1920. Collage on paper
mounted on paper,
7.6 x 11.4 cm. Private
Collection

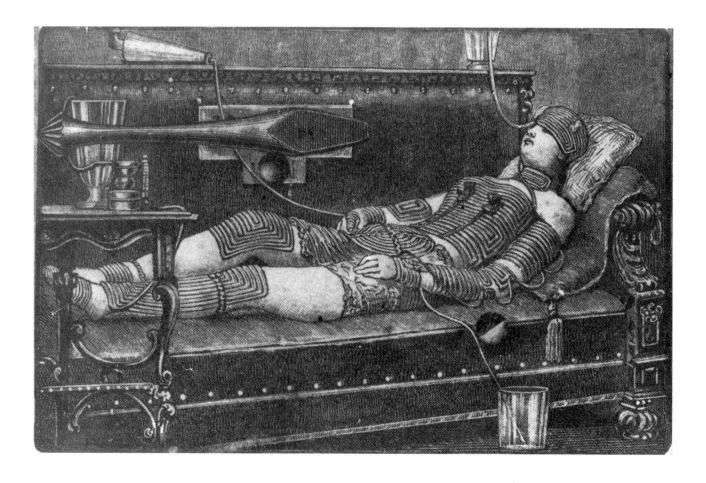

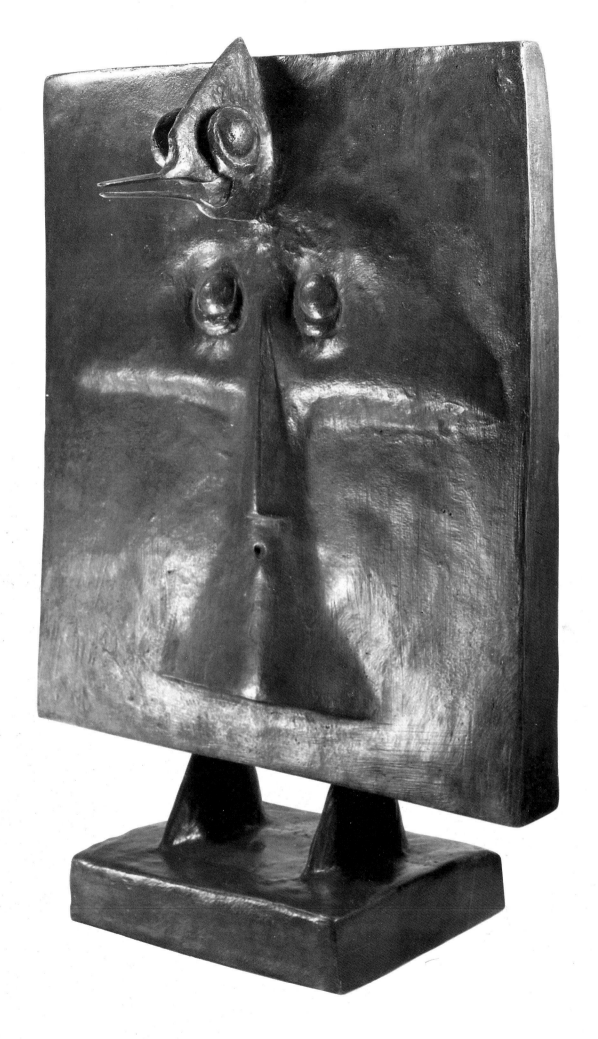

Rhine (Plate 44), a tribute to the river. As a more abstract work than others in which the decalcomania technique had been employed, *Old Father Rhine* presaged Ernst's increasing response to the importance of colour and form in French painting, which emerged fully in such pictures as *The World of the Naive* (Plate 47) and *The Marriage of Heaven and Earth* (Plate 48). This new interest in light and colour sustained him after the effective demise of Surrealism, which never reasserted itself after the war. Throughout his mature career colour had played a largely secondary role; being based on such techniques as photographic collage and pencil frottage, his art had responded to treatment in terms of light and dark.

Ernst continued to paint, largely in this light-hearted manner, but with occasional reversions (of a semi-serious nature) back to styles and methods of his Dada and Surrealist days, amidst growing acclaim, until his death in 1976. Numerous retrospective exhibitions of his work were held, one even in his home town, and in 1954 he was awarded the Grand Prize for painting at the Venice Biennale.

The variety and richness of Ernst's *oeuvre* makes him one of the most satisfying of twentieth-century artists. His genius lay in devising many and varied techniques for the treatment of his subject. His strength lay in refusing to illustrate an *a priori* theory but using his art as a tool of investigation. If he continues to engage our attention, it is because, as he put it himself: 'in yielding quite naturally to the vocation of pushing back appearances and upsetting the relations of "realities" [we have helped] to hasten the general crisis of consciousness due in our time.'

List of illustrations

Colour Plates

1 Flowers and Fish
1916. Oil on canvas, 72.6 x 61 cm.
Private Collection

2 Undulating Katherine
1920. Collage and gouache, 30 x 25 cm.
London, Private Collection

3 Hydrometric Demonstration
1920. Collage and gouache, 24 x 117 cm.
Paris, Galerie Jacques Tronche

4 The Hat Makes the Man
1920. Collage and watercolour, 35.6 x 45.7 cm.
New York, Museum of Modern Art

5 The Horse, He's Sick
1920. Collage, pencil, pen and ink, 14.5 x 21.6 cm.
New York, Museum of Modern Art

6 The Massacre of the Innocents
1920. Photocollage with gouache, 21 x 29.2 cm.
Chicago, E. A. Bergmann Collection

7 Celebes
1921. Oil on canvas, 125 x 107 cm. London,
Tate Gallery

8 Pietà, or Revolution by Night
1923. Oil on canvas, 116 x 89 cm. Turin,
Private Collection

9 Oedipus Rex
1922. Oil on canvas, 93 x 102 cm. Paris,
Private Collection

10 Woman, Old Man and Flower
1923-4. Oil on canvas, 97 x 130 cm. New York,
Museum of Modern Art

11 The Teetering Woman
1923. Oil on canvas, 130 x 97 cm. Düsseldorf,
Kunstsammlung Nordrhein-Westfalen

12 Men Shall Know Nothing of This
1923. Oil on canvas, 80 x 64 cm. London,
Tate Gallery

13 At the First Clear Word
1923. Oil on canvas, 232 x 167 cm. Düsseldorf,
Kunstsammlungen Nordrhein-Westfalen

14 Two Children Are Threatened by
a Nightingale
1924. Oil on wood and wood construction, 69.8
x 57 x 11 cm. New York, Museum of Modern Art

15 Who is this Tall, Sick Man ...
1923-4. Oil on canvas, 65.4 x 50 cm. Switzerland,
Private Collection

16 To the 100,000 Doves
1925. Oil on canvas, 81 x 100 cm. Paris,
Private Collection

17 Blue and Pink Doves
1926. Oil on canvas, 85 x 101 cm. Düsseldorf,
Kunstmuseum

18 Two Sisters
1926. Oil and frottage with black lead on canvas,
100 x 73 cm. Private Collection

19 Personnages, dont un sans tête
1928. Oil on canvas, 162.5 x 130.5 cm. Private
Collection

20 Monument to the Birds
1927. Oil on canvas, 162.5 x 130 cm. Paris,
Private Collection

21 On the Inside of Sight: The Egg,
1929. Oil on canvas, 98.5 x 79.4 cm.
Private Collection

22 Snow Flowers
1929. Oil on canvas, 130 x 130 cm. Belgium,
Private Collection

23 Cheval the Postman
1929-30. Collage, 64 x 48 cm. New York, Solomon
R. Guggenheim Museum

24 The Horde
1927. Oil on canvas, 115 x 146 cm. Amsterdam,
Stedelijk Museum.

25 The Great Forest
1927. Oil on canvas, 114 x 146 cm. Basle,
Kunstmuseum

26 Edge of a Forest
1927. Oil on canvas, 38 x 46 cm. Bonn, Stadtische
Kunstsammlungen

27 One Night of Love
1927. Oil on canvas, 162 x 130 cm. Paris,
Private Collection

28 Blind Swimmer: the Effect of Contact
1934. Oil on canvas, 93 x 77 cm. Collection of
Mr and Mrs Julien Levy

29 Loplop Presents
1931. Collage and pencil, 64.5 x 50 cm. London,
Private Collection

30 Garden Aeroplane-Trap
1935. Oil on canvas, 54 x 73.7 cm. Paris,
Centre Georges Pompidou, Musée National
d'Art Moderne

31 The Whole City
1935-6. Oil on canvas, 60 x 81 cm. Zurich,
Kunsthaus

32 Joie de Vivre
1936-7. Oil on canvas, 60 x 73 cm. Staatsgalerie
Moderner Kunst, Munich.

33 The Angel of Hearth and Home
1937. Oil on canvas, 114 x 146 cm. Paris, Private
Collection

34 The Robing of the Bride
1939. Oil on canvas, 130 x 96 cm. Venice,
Collection of Peggy Guggenheim

35 Napoleon in the Wilderness
1941. Oil on canvas, 46.3 x 38.1 cm. New York,
Museum of Modern Art

36 Europe After the Rain II
1940-42. Oil on canvas, 55 x 148 cm. Hartford,
Connecticut, Wadsworth Atheneum

37 Vox Angelica
1943. Oil on canvas, 152 x 203 cm. New York,
Acquavella Galleries

38 Breakfast on the Grass
1944. Oil on canvas, 68 x 150 cm. New York,
Private Collection

39 The Temptation of St Antony
1945. Oil on canvas, 108 x 128 cm. Duisburg,
Wilhelm Lehmbruck Museum

40 He Does Not See, He Sees
1947. Oil on canvas, 76 x 76 cm. Private Collection

41 The King Playing with the Queen
1944. Bronze, 97.9 cm high. New York, Museum of
Modern Art (gift of D. and J. Menil)

42 Young Man Intrigued by the Flight of
a Non-Euclidean Fly
1942-7. Oil and varnish on canvas, 82 x 66 cm.
Switzerland, Private Collection

43 After Me, Sleep
1958. Oil on canvas, 130 x 89 cm. Paris, Centre
Georges Pompidou, Musée National d'Art
Moderne

44 Old Father Rhine
1953. Oil on canvas, 114 x 146 cm. Basle,
Kunstmuseum

45 Coloradeau of Medusa
1953. Oil on canvas, 73 x 92 cm. Paris,
Private Collection

46 Almost-Dead Romanticism
1960. Oil on canvas, 32 x 23 cm. Milan,
Private Collection

47 The World of the Naive
1965. Oil on canvas, 115.8 x 88.7 cm. Paris,
Centre Georges Pompidou, Musée National
d'Art Moderne

48 The Marriage of Heaven and Earth
1962. Oil on canvas, 116.2 x 88.9 cm. Paris,
Collection of Lois and Georges de Menil

Text Illustrations

1 The Punching Ball or
The Immortality of Buonarotti
1920. Photo-collage, 176 x 115 cm. Chicago, Private
Collection

2 Kurt Schwitters
Dislocated Forces
1920. Collage, 105.5 x 86.7 cm.
Bern, Kunstmuseum

3 Giorgio de Chirico
The Philosopher's Conquest
1914. Oil on canvas, 126 x 98.5 cm. Courtesy
of The Art Institute of Chicago, Collection
Joseph Winterbotham Co.

4 Lithograph from 'Fiat Modes, Pereat Ars'
1919. 43.7 x 31.9 cm.

5 Le rendezvous des amis
1922. Oil on canvas, 100 x 195 cm. Wallraf-Richartz
Museum, Cologne

6 Mer et Soleil
1925. Edinburgh, Scottish National Gallery
of Modern Art

7 The Virgin Mary Beating the Infant Jesus
1926. Oil on canvas, 196 x 130 cm. Brussels, Private
Collection

8 Pablo Picasso
Figures by the Sea
1931. Oil on canvas, 130 x 195 cm. Private
Collection

9 Yachting
(from a collage novel entitled
La Femme 100 têtes)
1929. Collage, 8 x 10.8 cm. Paris, Private Collection

10 Culture physique, or
La mort qu'il vous plaire
(from a collage novel entitled
La Femme 100 têtes) 1929.

11 Oedipus
(from a collage novel entitled
Une Semaine de bonté)
1934. Collage, 28 x 20.5 cm.

12 The Lion of Bellefort
(from a collage novel entitled Une Semaine
de bonté)
1934. Collage, 28 x 20.5 cm.

13 Hans Bellmer
The Doll
c.1937-8. Photograph tinted with coloured ink,
53 x 53 cm. London, Tate Gallery

14 Head-Bird
1934-5. Bronze, 53 cm high. Private Collection

15 The Fruit of a Long Experience
1919. Painted wood relief, 45.7 x 38 cm. Geneva,
Private Collection

16 The Preparation of Glue from Bones
1920. Collage on paper mounted on paper,
7.6 x 11.4 cm. Private Collection

Comparative Figures

17 Here Everything is Still Floating
1920. Pasted photo-engravings and pencil,
10.5 x 12.4 cm. New York, The Museum
of Modern Art. Purchase

18 Francis Picabia
Machine Sans Nom
1915. Gouache and oil on cardboard, 120.6 x 66 cm.
Pittsburgh, Carnegie Institute

19 Stratified rock ...
1920. Collage with gouache, 15.2 x 20.6 cm.
New York, The Museum of Modern Art

20 Inscription on the reverse of 'Men Shall
Know Nothing of This'
London, Tate Gallery

21 Histoire Naturelle
1923. Oil on canvas, 232 x 354 cm. Paris, Private
Collection

22 René Magritte
The Use of Words
1928. Oil on canvas, 54.5 x 73 cm. Cologne,
Galerie Rudolf Zwirner

23 Francis Picabia
MI
1929. Gouache on cardboard, 160 x 96 cm.
Whereabouts unknown

24 The Fugitive
1925. Black lead pencil, 26.5 x 42.8 cm. Stockholm,
Moderna Museet

25 René Magritte
Pleasure
1926. Oil on canvas, 74 x 98 cm. Düsseldorf,
Nordrhein-Westfalen Collection

26 André Breton
Un Chevalier
1926-7. Sand, gesso, pencil and charcoal on canvas.
Private Collection

27 Showing the Head of her Father
to a Young Girl
1926. Oil on canvas, 65.5 x 81.5 cm. Private
Collection

28 Leonardo da Vinci
The Virgin and Child with Saint Anne
Paris, Musée du Louvre

29 Henri Rousseau
The Jungle: Tiger Attacking a Buffalo
1908. Oil on canvas, 172 x 191.5 cm. Cleveland,
Museum of Art

30 Salvador Dali
Soft Construction with Boiled Beans: Premonition
of Civil War 1936. Oil on canvas, 99 x 99 cm.
Philadelphia Museum of Art, The Louise and
Walter Arensberg Collection

31 Europe After the Rain I
1933. Oil and plaster on panel, 100 x 148 cm.
Zurich, Carola-Giedion-Welcker

32 Euclid
1945. Oil on canvas, 64 x 59 cm. Houston, Menil
Foundation

33 Illustration from 'Maximiliana'
1964. Original collage in Hamburg, Museum für
Kunst und Gewerbe

1 Flowers and Fish

1916. Oil on canvas, 72.6 x 61 cm. Private Collection

This early work shows Ernst drawing eclectically on a number of influences, from Cubism (especially the work of Robert Delaunay) in its colouration, to Futurism in the dynamism of its elements, mediated through the work of Franz Marc and Ernst's friend, August Macke. Even at this early stage, however, a number of themes which were to run, at least intermittently, through his entire work are apparent. This is particularly true of the subject matter, for while this is a still life with a Cubistic table in the foreground and even some suggestion of interior architecture, there are also hints at an underwater scene with fauna and flora which have taken on their own life. The appearance of fish here is premonitory, for they were later to be a staple of Surrealist iconography. That such themes were constant in an otherwise very diverse *oeuvre* is extraordinary, and suggests that while Ernst certainly rejected Expressionism and other straightforwardly avant-garde practices after the First World War, there were certain features which he retained and which were to find a renewed, if altered, life in Dada and Surrealism. Ernst wrote in an article in the magazine *Der Sturm* in 1917 of the mystical association of colours and their 'marriage': 'Blue and yellow are the first oppositions in colour of the coloured totalities of darkness and light, the measureless sphere of the firmament and the finite sphere of the earth...' Such oppositions were also a constant in Ernst's work, later much ironized, and later still perhaps restored to serious use.

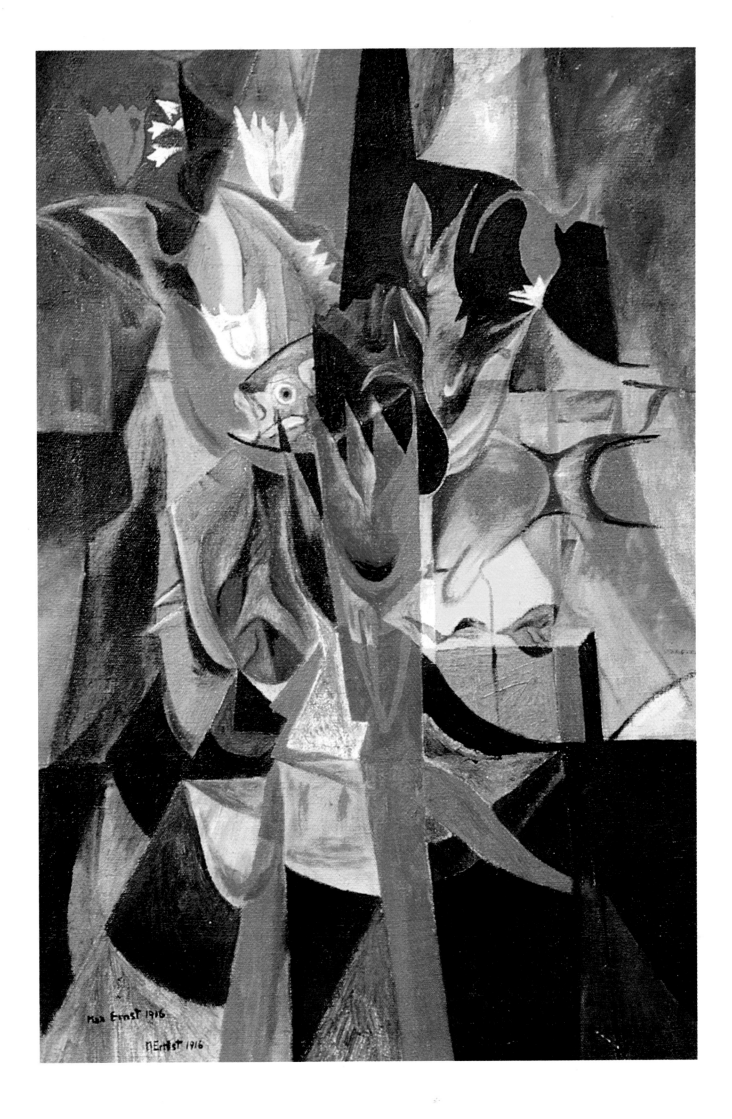

Undulating Katherine

1920. Collage and gouache, 30 x 25 cm. London, Private Collection

Ernst's early reputation was founded not on painting but collage, which used as its material many sources, particularly old journal and catalogue pages. He wrote of the 'hallucinatory' images of scientific catalogues: '...it suffices to add to the illustrations a colour, a line, a landscape foreign to the object represented – a desert, a sky, a geological section, a floor, a single straight horizontal expressing the horizon, and so forth. These changes, no more than docile reproductions of what is visible within me, record a faithful and fixed image of my hallucination. They transform the banal pages of advertisement into dreams which reveal my most secret desires'.

Collage could, however, mean many different things. Many of these collages were not actually cut and pasted but rather were 'found' images which Ernst subsequently overpainted. The basis for this collage is a piece of patterned wallpaper which runs continuously beneath the over-painting, with the exception of the band of paper of a slightly different pattern which runs at its base. In this work organic and mechanical elements form a hybrid object which has definite sexual connotations. The two poles around which the image is organized are exemplified by the floating cog wheel and the veinous, fleshy opening below. Ernst has manipulated elements to establish a ramshackle, provisional object-creature partially buried in the geological cross-section of a landscape.

In *Here Everything is Still Floating*, by contrast, a ship is constructed out of internal organs and floats in the sky alongside a fish (Fig. 17). Ernst's use of photomontage here is an indication of the diversity of means which he was able to use at this time, and the intention in this work is also quite different, being to create not a bizarre diagram but a fantastic illusionistic scene.

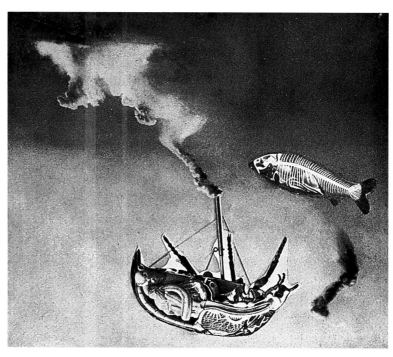

Fig. 17
Here Everything
is Still Floating
1920. Pasted photo-
engravings and pencil,
10.5 x 12.4 cm. New York,
The Museum of Modern
Art. Purchase

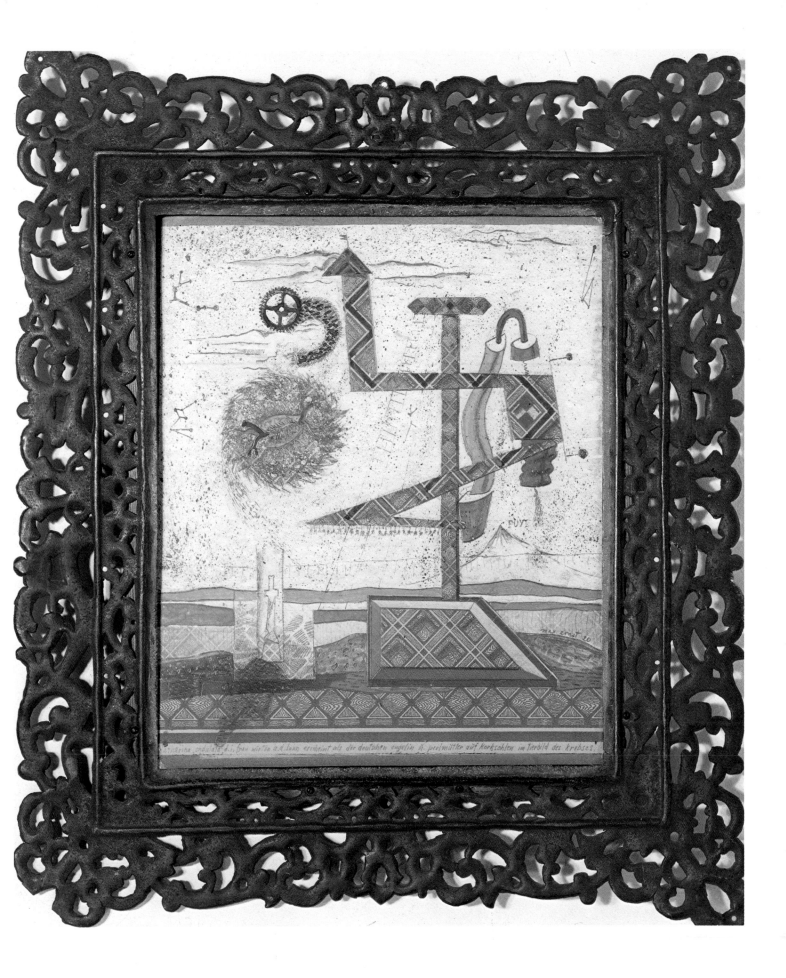

Hydrometric Demonstration

1920. Collage and gouache, 24 x 117 cm. Paris, Galerie Jacques Tronche

This is one of the works which caused a sensation at the Au Sans Pareil Gallery's exhibition in 1921. Although collage had been much used by the Cubists, Ernst employed it for quite different ends. Writing later in his book *Surrealism and Painting*, André Breton noted that Ernst had produced 'the unrestorable fragments of the labyrinth ... a jigsaw puzzle of creation.' Collage elements were not associated to create formal ensembles which played with issues of representation. Rather they maintained their separateness, having what Breton called a 'relatively independent existence', in which subject matter was highly important. Pieces were forced away from their usual context and sought new ones, although this was done without 'violence' to the elements. We should note that for Breton the puzzle was unrestorable, its solution remaining forever elusive.

If the results of this process were sometimes menacing, said Breton, this was to be expected, for it was only natural 'that we should be seized with horror by the things of this world...' The subject of this work, of which the full title is *Hydrometric Demonstration of Killing by Temperature*, is clearly related to the First World War and particularly to the great advances in the technology of slaughter devised during that conflict. Ernst used illustrations of scientific and medical equipment, and an exaggerated perspective derived from de Chirico, to give the work an air of objective menace. After the War, which saw the use of gas and the first aerial bombardment of cities, it was widely considered that all life on earth could be swiftly ended by the new weaponry: such views were expressed by writers as diverse as Blaise Cendrars and Georges Clemenceau. The paranoia about laboratories creating secret and ever more deadly weapons is signalled in *Hydrometric Demonstration*, with its complicated killing and measuring apparatus deployed in a closed room. The technical and logical approach to killing during wartime, which produced such insane and chaotic results, was a fundamental factor behind the Dada rejection of reason. It is apparent in many of Francis Picabia's works (Fig. 17) which sometimes closely approach those of Ernst.

Fig. 18
Francis Picabia
Machine Sans Nom
1915. Gouache and oil on
cardboard, 120.6 x 66 cm.
Pittsburgh, Carnegie
Institute

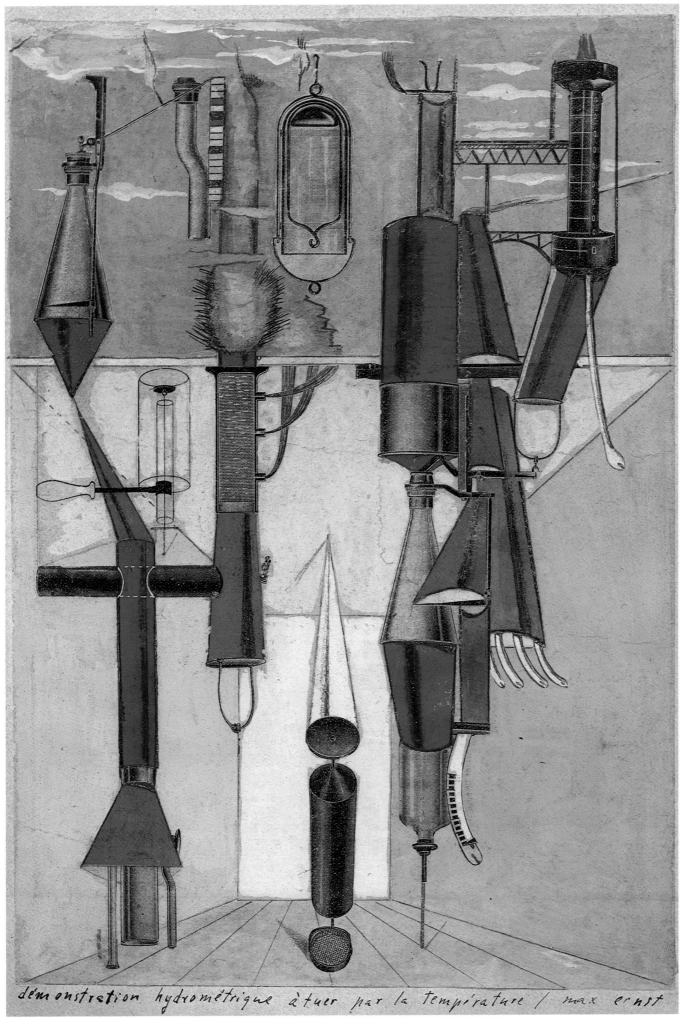

démonstration hydrométrique à tuer par la température / max ernst

4 The Hat Makes the Man

1920. Collage and watercolour, 35.6 x 45.7 cm. New York, Museum of Modern Art

Here a sequence of hats taken from the page of a catalogue is connected with coloured strips to create ramshackle figures. Most of the hat-figures are left as they appeared on the page, first isolated by overpainting and then joined with coloured strips. The left-hand 'figure' differs from the others in being a cut collage of hats, some inverted. In his essay introducing Ernst's work at the Au Sans Pareil Gallery, Breton had stressed 'the marvellous faculty of attaining two widely separate realities without departing from the realm of our experience; of bringing them together and drawing a spark from their contact ...' The combination of diverse images in Dada imagery was supposed to create a revelatory spark as the two were brought into contact, and the method is clearly illustrated in this collage. Breton claimed that Ernst's collage technique was to combine elements literally at random, and if these combinations were actually to be found in reality this was against enormous odds and proved their lyrical force. He mentioned *Pietà or Revolution by Night* (Plate 8) and *Two Children Are Threatened by a Nightingale* (Plate 14) as examples of this effect. Despite Breton's claim, not much in these works happens by chance, of course, but nor were the effects of the collages due solely to the conscious manipulation of the artist, who was after all dealing with found material.

A commonplace of Dada thought at this time was that modern Western people were ready-made puppets, manipulated by commercial forces, and that this was as true of intellectual production as of consumerism. In 1921 André Gide compared the mind of Maurice Barrès (the French right-wing propagandist) to a machine for making hats. Any material fed into this machine, Gide wrote, would emerge as a hat, even children, who would at last become useful for something. Hats, aside from being an indicator of social status and also (for Freud) a sexual symbol, are used here as indicators of the ready-made, manufactured status of modern people. The connection between word and image in these works is far from clear, though in *The Hat Makes the Man* Werner Spies has appropriately connected the compound word *stapelmensch* with social climbing. The use of words in Ernst's art was very important, the titles and additional inscriptions being presented as part of the work. Here in the German text nonsense combination-words are connected in a condensed, catalogue-type style as though they were captions to the image. The writer Louis Aragon claimed that titles in Ernst's work took on the dimension of poetry, a typical Dadaist device. Ernst's closeness to Picabia in regard to machine imagery has been noted, but their use of inscriptions within the work also had similarities. In both cases, the linkage of word and image may be more puzzling than revelatory, for the writing often conflicts with or is only obliquely related to the subject. Ernst's collages have been compared with the verbal associations of the Symbolists, for which they are a visual analogue. Sometimes the words are collaged in the titles, for instance in *Phallustrade*, in which a single word joins two images in the same way that collages work with visual material.

bedecktsamiger stapel-
mensch nachtsamiger wasserformer
(paddelformen) kleidsame nervatur
auch
! umpressnerven!
(c'est le chapeau qui fait l'homme)
(à style c'est à tailleur)

max ernst

The Horse, He's Sick

1920. Collage, pencil, pen and ink, 14.5 x 21.6 cm. New York, Museum of Modern Art

This collage was one of a series of similar motifs, there being another collage version in 1920, followed up later by a frottage and a painting. The other work of 1920 is more brightly coloured and has stronger suggestions of a grassy ground and sky. In both cases the 'flower' below the horse's nose is in fact the front foot, repeated and inverted. Collage was later described by Ernst as a 'pure act', like love, 'the coupling of two realities, irreconcilable in appearance, upon a plane which apparently does not suit them'. In this case a highly disturbing mix of the mechanical and the organic is brought together in a hybrid, an image of corporeal corruption and objectification.

In *Stratified Rock gift of nature composed of gneiss lava Icelandic moss 2 varieties of bladderwort 2 varieties of perineal damcrack cardiac vegetation (b) the same in polished casket more expensive* (Fig. 19) we also see an organic assemblage of forms situated in a landscape. These forms threaten to construct a creature, but do not quite achieve it, though there is an attempt at a disturbing integration of mineral, mechanical and organic elements. These pictures are like working diagrams, using cross sections and employing a strict pictorial division of parts. The hybrid forms of both pictures, which Ernst often used throughout his work in different guises, are reminiscent of the hideous experiments of science fiction, and both works may be related to contemporary literary equivalents, especially to H.G. Wells' *The Island of Doctor Moreau*. The activity of Moreau in creating human-animal hybrids by cutting and stitching mismatched found parts finds its exact pictorial counterpart in Ernst's grisly collage activity. Dada sought to bring the means of war to bear on culture and in such works as these Ernst apes the division and mechanization of the body in war in a form of hideous *bricolage*.

Fig. 19
Stratified rock ...
1920. Collage with
gouache, 15.2 x 20.6 cm.
New York, The Museum
of Modern Art

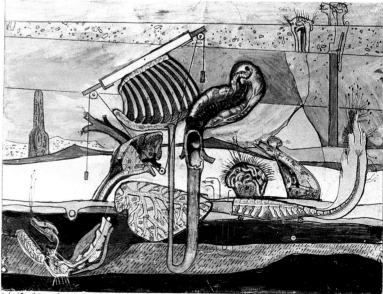

6 The Massacre of the Innocents

1920. Photocollage with gouache, 21 x 29.2 cm. Chicago, E. A . Bergmann Collection

Some works by Ernst directly refer to modern war, notably *The Massacre of the Innocents*, with its irrational spaces, simulating mental and physical disorder, and elements of condensation (the columns that are also railway sleepers), the fliers and the upturned city. Such works, made soon after the end of the First World War, are unusual in Ernst's work in being relatively clear statements about a particular issue, in this case the aerial bombardment of cities.

Ernst wished to make the collages appear seamless, to give some illusion of pictorial unity, against which disruptive effects of scale, orientation and the contrast in diverse subject matter could work. The images of the running figures are stencilled and coloured by hand, while the railway tracks are constructed from photographs of the façades of Venetian buildings laid on their sides, as though casualties.

Ernst used material from old illustrations, and their character, of being a little out of date, of giving off a musty air, was a highly important component of his work. This was true not only of the subject matter but also of the style of the collages and even the paintings with their awkward, ramshackle character. According to Louis Aragon, archaism in Ernst was a way of seeing the future through the past. Later Walter Benjamin wrote of Surrealism that 'It was the first movement to come across the revolutionary energies contained in the 'outmoded', in the first iron structures, the first factory buildings, the earliest photographs, in objects on the verge of extinction – grand pianos in drawing rooms, the clothes of five years ago, fashionable gathering places when the vogue begins to desert them'. Ernst consistently used such material which, precisely because it is slightly estranged from the viewer, is free of its commercial and utilitarian function.

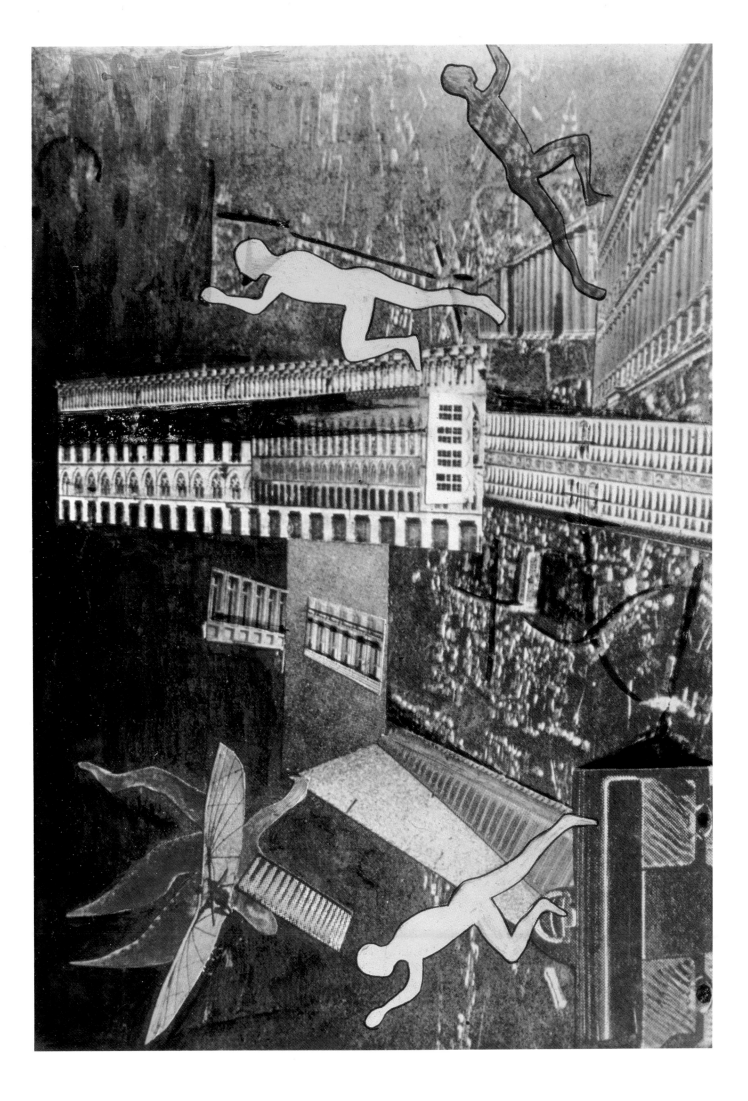

Celebes

1921. Oil on canvas, 125 x 107 cm. London, Tate Gallery

Celebes is one of a group of painted collage constructions. The elements in the painting are found and then manipulated, some of the sources in *Celebes* being identifiable. These painted 'collages' have a precise, rather dull technique, and the point of rendering them in paint was certainly not purely aesthetic. Painting rather than pasting collage did confer definite advantages: there were no joins to conceal, the scale of the elements could be altered, as could their style, and the size of the work as a whole could be increased. Furthermore, these works were manifestly constructed as puzzles, in which discrete elements were played off against one another. We think of these pictures in terms of constituent units which are very clearly separated, in a way that we could never do with Ernst's earliest paintings.

Examining the diverse elements in the picture leads the viewer to speculate about its meaning: the metallic hull of the 'elephant' itself; the construction on the top of the elephant, which is very reminiscent of figures by de Chirico; the headless, plaster-like female figure; the flag pole to the left of the elephant; and the fish flying in the sky along with a smoke trail. The nautical sky of the picture is a commonplace of mirage and hallucination and was frequently used in Ernst's work and in Surrealist painting as a whole. The armoured, mechanical elephant is related to other organic-mechanical compounds in Ernst's *oeuvre*. The reference to gas masks in its tubular trunk brings the viewer back to the war, while the whole machine may be read as a tank, in which case the trunk becomes a pliable, organic weapon. The smoke trail in the sky is another indicator of war as may be the mechanistic, cylindrical figure to the right, which is related to the hat-figures in *The Hat Makes the Man* (Plate 4).

Ernst thus created a rebus, a picture puzzle, from partially familiar elements which have reference to particular painters, his own work, the history of art, and recent events. Readings can be begun which appear to unravel the puzzle, as with the reference to war, but consistent interpretations which would explain the whole are generally frustrated. Other aspects are left deliberately mysterious. The word 'Celebes' probably comes from a scatological rhyme which Ernst knew from his schooldays: at the time this was, of course, a private association.

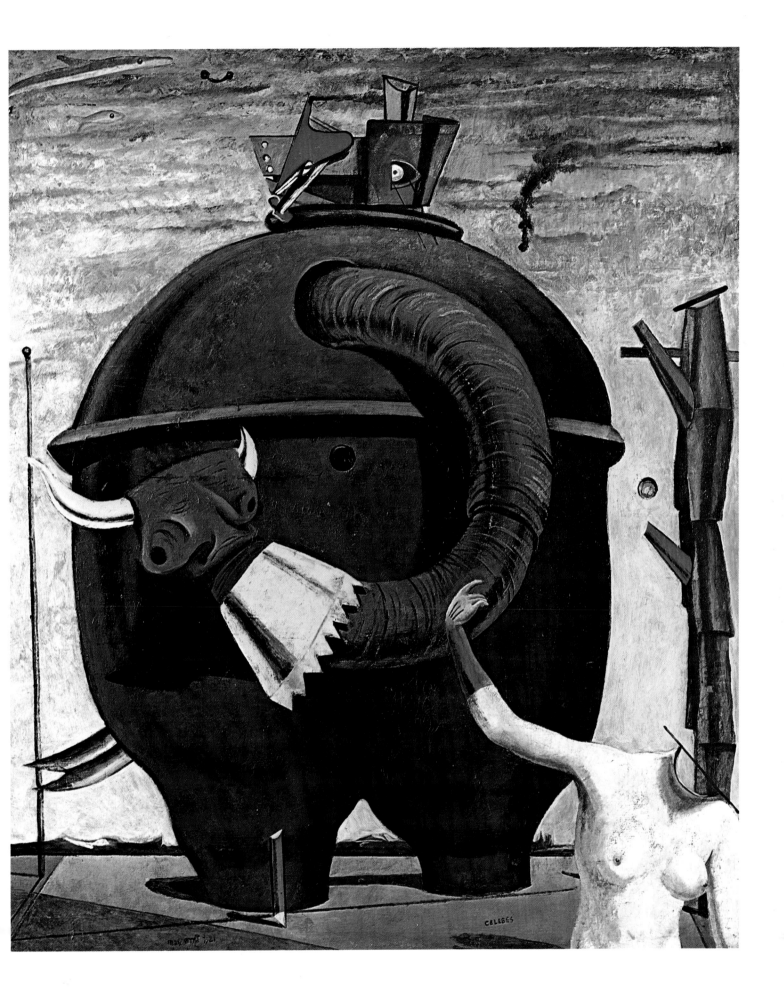

Pietà, or Revolution by Night

1923. Oil on canvas, 116 x 89 cm. Turin, Private Collection

This work has generally been interpreted as a psychoanalytical puzzle in which the stone-headed figure is identified as Ernst, and the moustachioed character carrying him as the artist's father. Ernst modified the theme of the Pietà by having the Christ figure borne by the father rather than the mother. These interpretations are based on various autobiographical and art-historical factors: Ernst's account of his father, an amateur painter, portraying him in the role of the infant Jesus, and another account where his father's moustache is mentioned. There is some vague resemblance between Ernst and the stone figure, and likewise some similarity between the moustachioed figure and the paternal figure in de Chirico's well known painting, *The Child's Brain*. If the identifications are accepted, then Ernst appears to have cast himself in the role of the insane through his stony catatonia and his mental patient's white smock, in contrast to the bourgeois order exemplified by his father's conventional dress, while underlying the scene are the usual Oedipal forces and fears of castration. It is certainly true that in articles from 1927 onwards, Ernst constructed for himself a mythical psychobiography, which drew on and attempted to explain elements of his work in a classical Oedipal construction in which he witnessed or fantasized a sexual act between his parents. Before this obfuscating 'explanation' was provided by the artist, the status of the picture was somewhat different. It is possible that those personally close to the painter (André Breton and the Eluards) knew about these things from the beginning, but this is beside the point. What we are looking at in Ernst's mythic autobiography is a fabricated artifact, every bit as much a work of art as the *Pietà* itself: therefore it is foolish to expect one to explain the other.

Such interpretations also run into difficulties because they fail to explain each feature of the work. It has been pointed out that the three figures in the *Pietà* embody the techniques of sculpture, painting and line drawing, and this immediately adds another layer over the psychoanalytical structure, the connections between the two being far from clear. The role of the third, bearded, figure is in any case a puzzle: some have seen it as the ghost of the poet Guillaume Apollinaire, wounded in the war – but why should he be here? Others have noted a similarity to Sigmund Freud – but why should Freud's head be bandaged? The figure has also been read as another representation of the father – but it is difficult to argue this and at the same time present moustaches as an identifying paternal feature.

The subtitle 'Revolution by Night' refers to dreaming, to the Surrealist combination of material and mental revolution. Certainly rebellion against the patriarchal father, against reason itself, was related by the Surrealists to an idealist notion of political revolt. It may be that we should see contradiction and ambiguity as Ernst's way of gaining greater, but non-rational, insight.

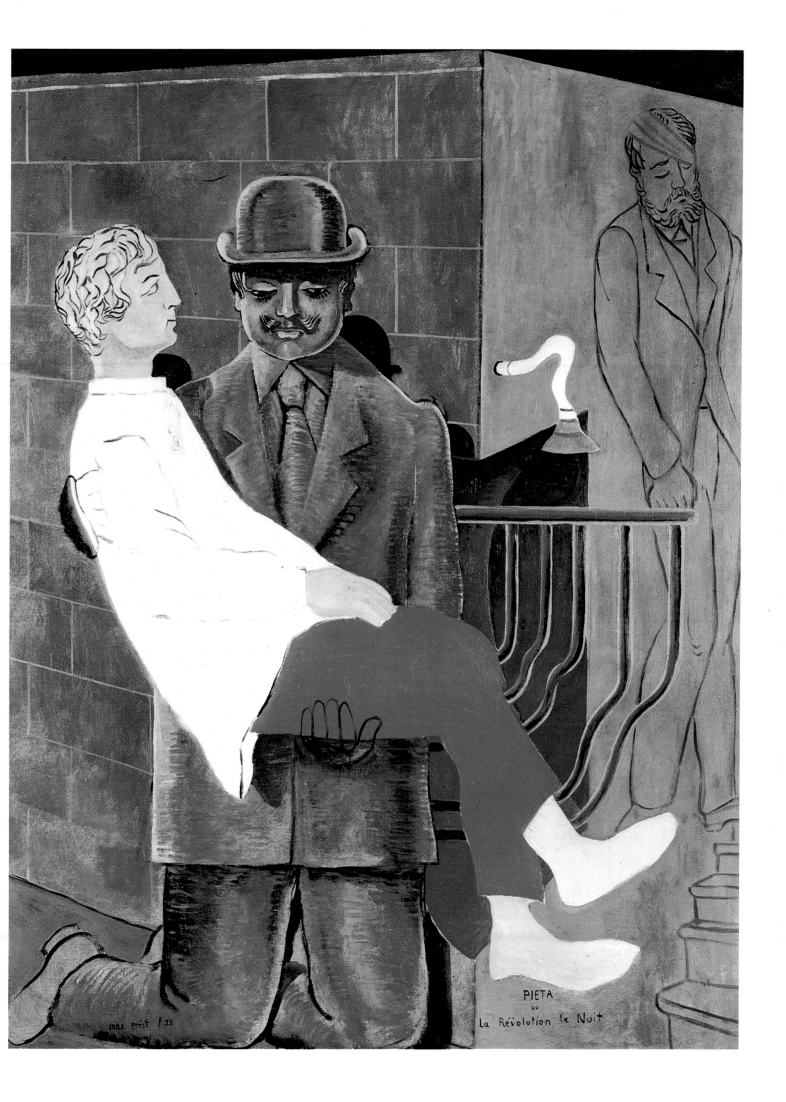

Oedipus Rex

1922. Oil on canvas, 93 x 102 cm. Paris, Private Collection

In Ernst the juxtaposition of collage elements is often like a sentence lacking connectives. The viewer naturally attempts to compensate for these gaps, but is frustrated in doing so. In *Oedipus Rex* these collage elements are arranged with the clarity of clues, as though the painting has taken on the role of the Sphinx in the Oedipus myth: it poses a riddle, presented here in the form of a rebus. There is a suggestion of an unwelcome truth in the awkwardness and dislocation of the painting, hidden by its unintelligible character. In automatic writing, possession was deliberately courted as a means of short-circuiting language, of drawing words from their meanings and in so doing establishing magical connections between disparate concepts. Though there is nothing 'automatic' about them, the aim is similar in Ernst's collage paintings.

In the illustrations Ernst made for Paul Eluard's *Répétitions*, there appears a very similar image in which the walnut is replaced by an eye. Here the device held in the hand is more readily identifiable as a machine for marking the feet of birds. This, along with the title, direct us to the legend of Oedipus, who was crippled and abandoned by his parents and who later blinded himself in remorse for his acts against his family. Oedipus was also the only mortal able to answer the riddle of the Sphinx, so Ernst is holding out to each viewer the forlorn hope that they too will be able to solve this picture-puzzle. The legend was important for Freud, not only because of Oedipus's actions towards his parents, but because psychoanalysis also deals with the riddle posed by the symptoms of neurosis. Blinding is a symbol of castration in Freud's writings, and the walnut an old symbol of the womb. The pierced fingers and the walnut shot through with an arrow are symbols which stand for more than one thing. This condensation is apparent in the tips of the fingers appearing from behind the walnut, which take on the form of breasts.

More generally, restriction of movement is a theme of the painting, in the hands poking through the hole in the wall (which cannot withdraw while pierced by the device), in the animal heads protruding through the floor and fenced about, and in whatever is tied to the bull's horns that floats in the air out of view. Extreme freedom of movement, embodied in the flight of the balloon, appears in the distance. There is a sense that the unanswered riddle is a trap.

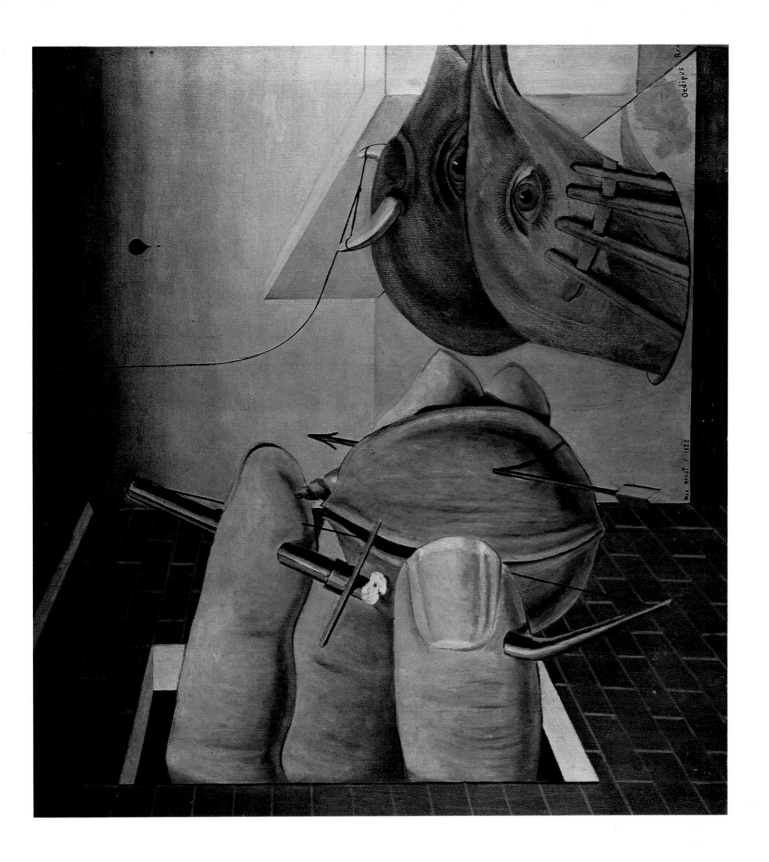

Woman, Old Man and Flower

1923-4. Oil on canvas, 97 x 130 cm. New York, Museum of Modern Art

This work has often been the subject of psychoanalytic interpretations, usually based on a reading of an earlier version of the work (extensively overpainted by Ernst) in which the figure on the left cradling a naked woman can be identified as the father. Elizabeth Legge has argued that the figure may be related to Freud's Wolf Man, for as in that case study it appears to be a lion-wolf hybrid. It is as if the painting itself had a psychoanalytic history which we are fortunate enough to be able to read and that the identities of the figures are carried through to the final version. Ernst was using other structures than the psychoanalytical here, however, since the sexual ambiguity of the flower figure may be related to the theme of hermaphroditism in alchemy, and more broadly to the uniting of opposites, a matter which fascinated not only Ernst, but other Dada and Surrealist artists and writers. Essential to Surrealist thought was a region of the 'Beyond' where, in a schema partly inspired by the German philosopher Hegel, all contradictions (the product of instrumental rationality) would be dialectically resolved. In the *Second Manifesto of Surrealism* (1929) Breton wrote: 'Everything leads us to believe that there exists a certain point in the mind where life and death, the real and the imaginary, past and future, the communicable and the incommunicable, high and low cease to be perceived as contradictory.' Such a concept was shared by Freud who wrote that 'The highest and the lowest are always closest to each other in the sphere of sexuality: 'From Heaven, across the World, to Hell'.' An extreme is reached which folds back on itself as make contact with its opposite in a manner which is precisely analogous to the Surrealist short-circuit in metaphor and collage. This meeting place of opposites was often associated with the fourth dimension, a realm of spirit, where the aesthetic might lurk, something separate from but vital to the mechanism of art: this is just where logic is broken and contradictions are encompassed.

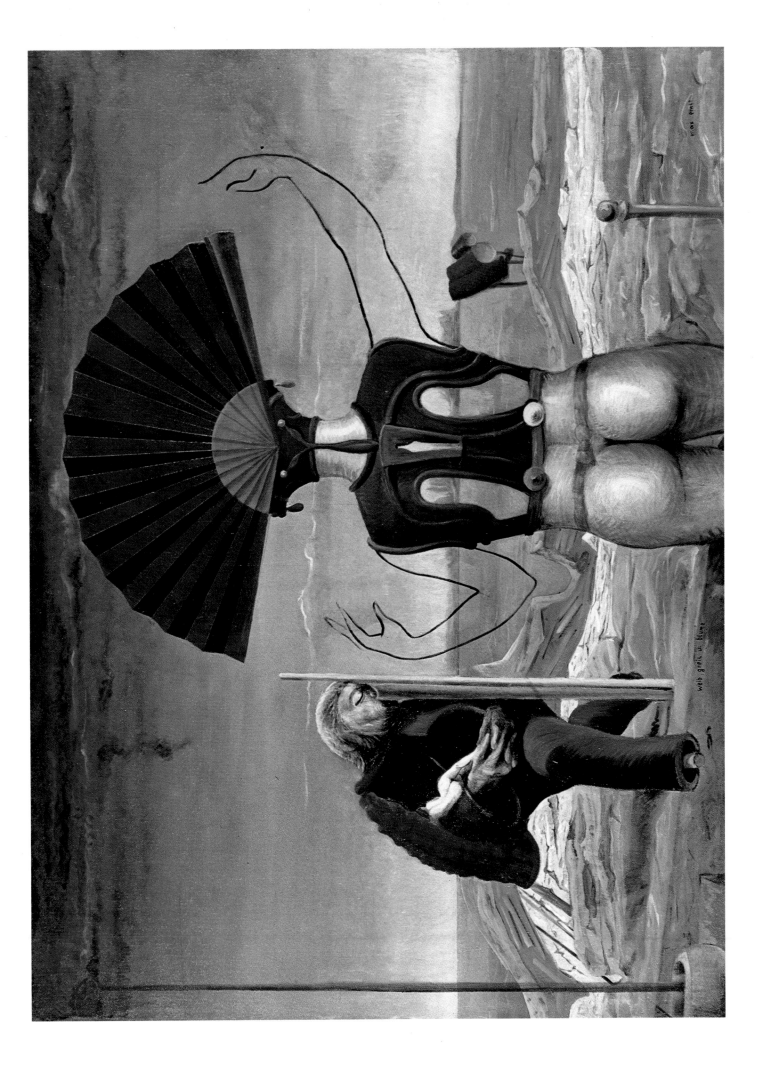

11 The Teetering Woman

1923. Oil on canvas, 130 x 97 cm. Düsseldorf, Kunstsammlung Nordrhein-Westfalen

In this picture, there is a basic ambiguity concerning the relation of the woman to the mechanism. Is she enclosed, trapped and tortured by the machine, or is she its controller and guide? The woman's eyes are covered by a tube and so blindness is also a feature of this work. Despite the angle at which she is held or leans, and her upright hair, there is a stillness about the pose which suggests sleepwalking. A reading of this activity as torture means that this picture conforms with other similar works, such as *The Preparation of Glue from Bones* (Fig. 16), in which a female figure swathed in a tubular garment lies on a couch, attached by tubes to various apparatus; the head of a large screwdriver hangs over her menacingly. Other works by Ernst, particularly *Physical Culture*, also appear to reflect the writing of Raymond Roussel. In re-using medical illustrations of the nineteenth century in his collages, Ernst often addressed the much discussed issue of the link between medicine and torture. In *Teetering Woman*, however, Ernst does not give the viewer many clues to help in deciding between the two possibilities: there is a marked lack of authorial comment in these works which react against emotive Expressionism. The handling remains neutral, imparting an air of scientific detachment.

The distant view of water in the background and the presence of columns or chimneys are both reminiscent of de Chirico's work. The sources for the elements in this painting have been found in nineteenth-century French magazines: the woman is an acrobat originally shown hanging upside down (hence the hair) and inverted by Ernst, a strategy he often used. The machine is a device for spreading oil on water, and Ernst has transformed the regular spouts of oil into solid bars. There is a question about what level of explanation such originally inaccessible sources provide for the painting. It may even be that a knowledge of the source material detracts from an appreciation of the enigma of the work, and it seems doubtful that the iconography of the sources should be used as the basis for interpretation, given the great disjunction between these sources and the final picture.

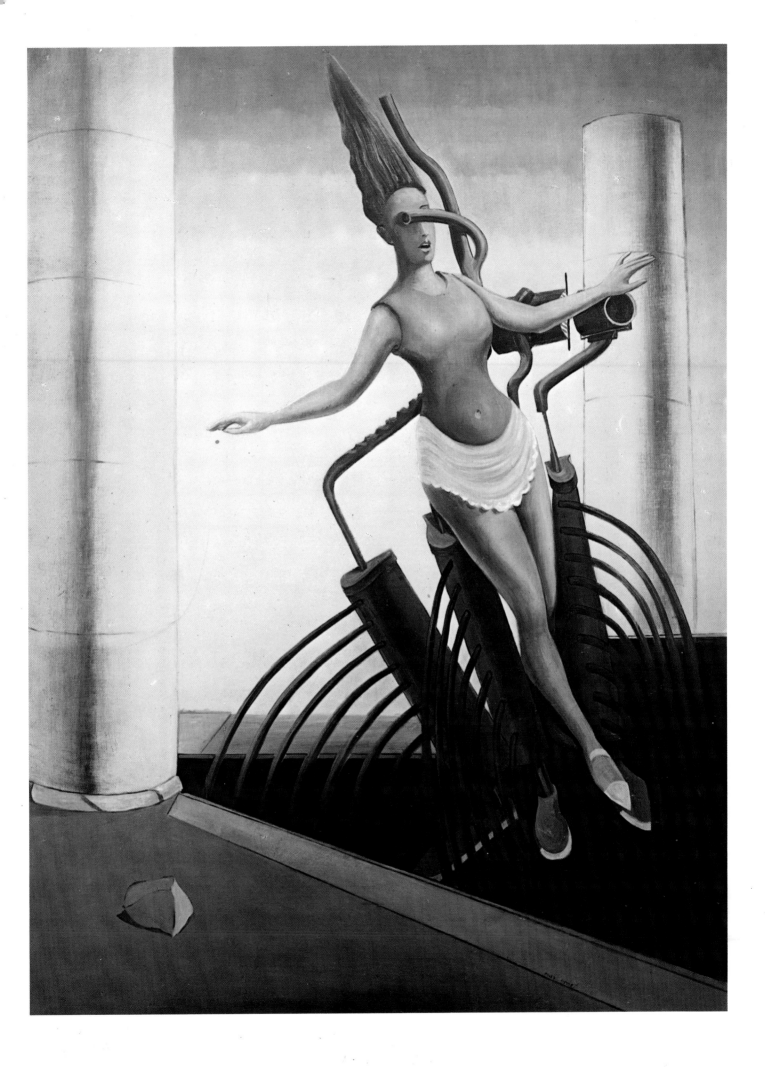

1923. Oil on canvas, 80 x 64 cm. London, Tate Gallery

Fig. 20
Inscription on
the reverse of 'Men
Shall Know Nothing
of This'
London, Tate Gallery

This picture, perhaps more than any other work by Ernst, has elicited varying detailed explications, yet the title of the work itself is a warning against such readings. A poem, dedicated to the owner, André Breton, was pasted to the back of the painting (Fig. 20). The text of the poem is as follows:

> The crescent moon (yellow and parachute-like)
> prevents the little whistle from falling to
> the ground
> Because someone is paying attention to it, the
> whistle thinks that it is rising to the sun.
> The sun is divided in two, the better to
> revolve.
> The model is stretched out in a dream-like pose.
> The right leg is bent back (a pleasing and
> precise movement).
> The hand shields the Earth. By this motion,
> the Earth takes on the importance of a sexual
> organ.
> The moon goes very quickly through its
> phases and eclipses.
> The picture is odd in its symmetry. The
> two sexes balance each other there.

This text appears to parody alchemical language and imagery. Geoffrey Hinton has made a very close reading of this work in the light of Freud's Schreber case, where the sun stands for God and the father, the moon for the mother, where the sun's rays are attached to the body, and where Schreber saw himself as a hermaphrodite. It is unclear how far the public meaning of a picture can be dependent on a specific reading made in relation to a single theoretical text. This is particularly the case with psycho-analytic readings where identifications are usually arbitrary, private and frequently contradictory. Elizabeth Legge has speculated that the work may be a sceptical statement about the possibility of attaining knowledge of the Beyond as sought in alchemy, and the title would appear to confirm this.

In *Men Shall Know Nothing of This* the movements of moon and earth are related to sexual activity. Ernst also made a similar association in *Mon Petit Mon Blanc* where planetary movements and sex are equated with a woman's buttocks stuck through the rings of Saturn, while an object like a gun hovers above them. Such associations may seem eccentric, but had their basis in alchemy and were not confined to Ernst: Francis Picabia's linking of wheels and the sexual act, and certain poems by Blaise Cendrars, present similar relations.

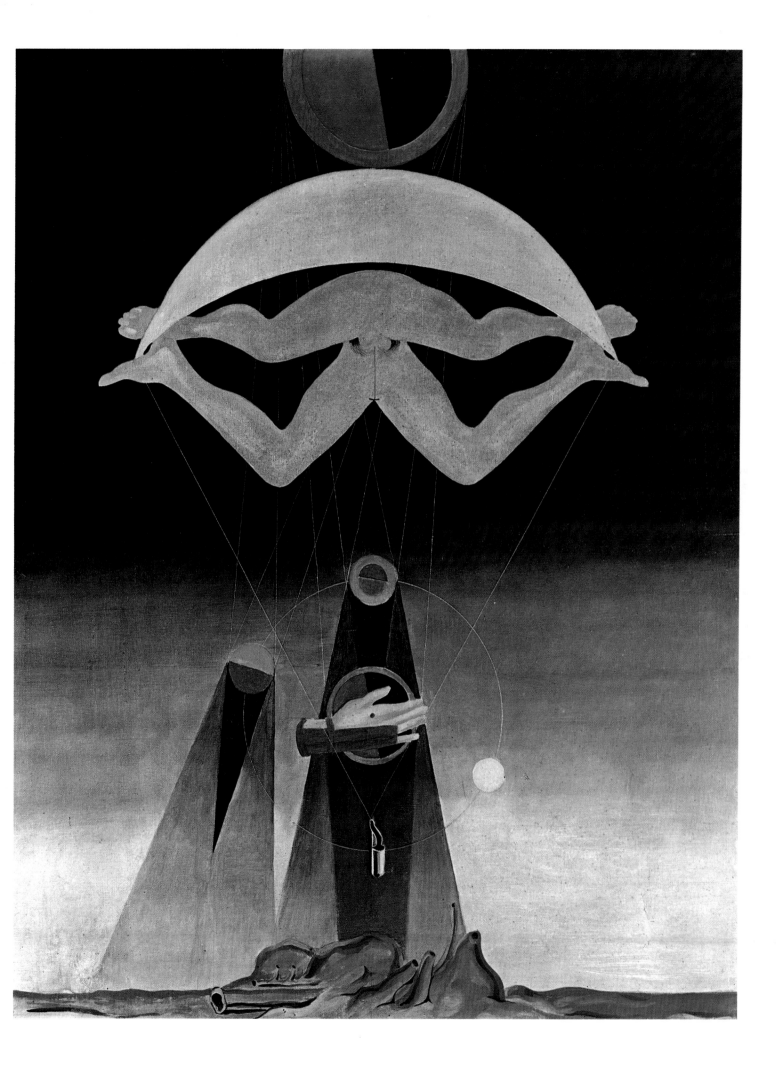

At the First Clear Word

1923. Oil on canvas, 232 x 167 cm. Düsseldorf, Kunstsammlungen Nordrhein-Westfalen

Fig. 21
Histoire naturelle
1923. Oil on canvas,
232 x 354 cm. Paris,
Private Collection

Following their collaboration on *Les Malheurs des immortels* and *Répétitions*, Ernst stayed at Paul Eluard's house in Eaubonne in 1923-4, where he painted a number of pictures on the walls and doors. These were later painted and papered over and were only uncovered in 1967. Those that could be salvaged were then detached from the walls and restored. *At the First Clear Word* formed part of this picture sequence, which represented a curious, formal, probably Mediterranean garden (Fig. 21). In this panel a hand again protrudes through an opening; just as the fingertips in *Oedipus Rex* become breasts, so the fingers holding the fruit here double as female legs. The signature was added later, as was the title of the work, which was taken from a poem by Eluard. This image should probably be seen as part of the mural sequence rather than as an independent work in its own right.

This has not prevented some interpreters from reading the image in isolation as an oblique set of references to Jensen's story *Gravida*, set in the ruins of Pompeii, and used as the basis for an analysis by Freud (and now largely remembered because of this). The stick insect on the wall has been tenuously identified with the fly which settles on the hand of Gradiva in the story. The string which leads from the insect to the ball may be seen to form the letter 'M' (perhaps for Max) which has led commentators to believe that Ernst's own identity and circumstances are written into this work, and to speculate about the triangular relationship between Ernst, Paul and Gala Eluard, and their own constructions of a Gravida myth around their own lives. However this may be, the use of such signs in the work is extremely obscure.

Charlotte Stokes has shown how Ernst used material from experiments illustrated in the nineteenth-century scientific journal *La Nature* in this picture. The ball with the crossed fingers was derived from an illustration showing that when a person performs this act the presence of two balls is perceived. It could be argued that the work thus refers to the divided, hysterical self, as indeed it may have done privately for Ernst. However, the chances of the viewer correctly identifying the experiment for what it was seem remote, and there are many more obvious representations of the divided self in Ernst's work.

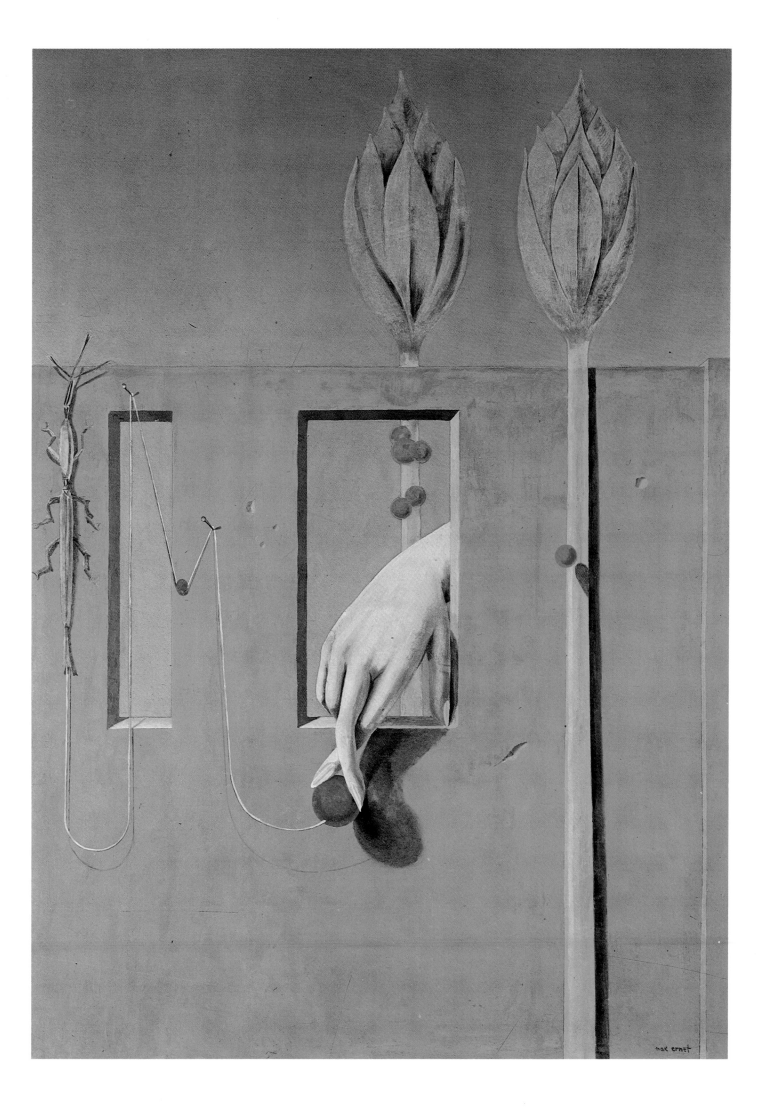

Two Children Are Threatened by a Nightingale

1924. Oil on wood and wood construction, 69.8 x 57 x 11 cm.
New York, Museum of Modern Art

Long after he painted this work, Ernst described in *Beyond Painting* a fever vision from his childhood in 1897, as part of the long construction of his psychobiography. This event seems to have some connection with this painting: 'First contact with hallucination. Measles. Fear of death and the annihilating powers. A fever-vision provoked by an imitation mahogany panel opposite his head, the grooves of the wood taking successively the aspect of an eye, a nose, a bird's head, a menacing nightingale, a spinning top and so on. Certainly little Max took pleasure in being afraid of these visions, and later delivered himself voluntarily to provoke hallucinations of the same kind in looking obstinately at wood-panels, clouds, wallpapers, unplastered walls and so on ... ' The reading of forms into given patterns was to be crucial to his later work.

Doors and gates are Freudian symbols signifying sexual availability or virginity, depending on whether they are open or shut. The nightingale has been identified in a more private way with Ernst's father, so some sort of reading of this work in terms of abduction and seduction seems possible. However, such interpretations founder on the mismatch of title and image, and on the many unexplained elements. One theme may be the relation between painting and reality: the male figure's painted hand reaches for a real door knob. The addition of this knob to the side of the picture seems to turn the whole painting into a door which could be opened to reveal what lies beyond.

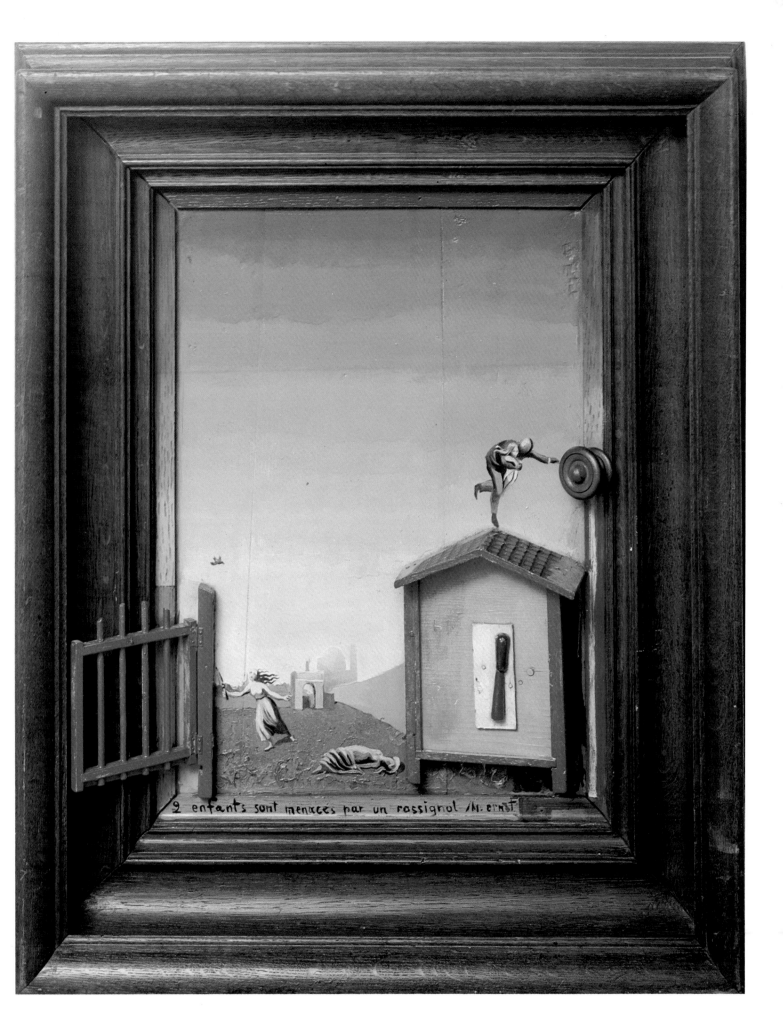

2 enfants sont menacés par un rossignol /M. ernst

1923-4. Oil on canvas, 65.4 x 50 cm. Switzerland, Private Collection

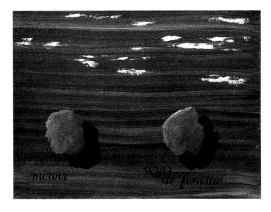

Fig. 22
René Magritte
The Use of Words
1928. Oil on canvas,
54.5 x 73 cm. Cologne,
Galerie Rudolf Zwirner

Words were often an integral part of Ernst's work. The word-image association was taken further in the 1924 *Picture-Poems* where words are strung together and act as objects, even casting shadows. They recede in space, wrap themselves about objects and may be transparent or opaque. These words are not representations of newsprint (as in pre-First World War Cubist work) or collaged elements, but pictorial objects of the same material and status as the represented forms about them. A point is made about the equivalence of word and image as representation, about the concreteness of signs. Amidst the classical columns and steps, the couples dance or struggle, and seem bound by the words spun about them. The dead bird on the floor is probably a symbol of lost freedom.

René Magritte exploited similar means to explore the arbitrariness of signs by making words act as objects, and images as words. His painting illustrates the failure of linguistic and visual signification, pointing to the impossibility of establishing contact with the 'real' object. Sometimes, as in *The Key of Dreams* (1930), representations of objects and captions appear linked in boxes but the captions contradict the images, a bowler hat being labelled 'snow', for instance. At others, as in *The Use of Words* (Fig. 22), indeterminate objects are given definitive labels. The images are themselves generally quasi-conceptual, pictures of the explanatory type which appear in catalogues or encyclopedias. Magritte does not present a mismatch of objects and signs but rather of visual and verbal signifying systems. Magritte played with these concepts, and claimed a special status for the painted form, writing, 'In a painting, the words have the same substance as the images', a condition which does not hold elsewhere. Words become material, embodied in paint, and objects are dissolved in representation, meeting halfway in their mutual transformation. In the works of both Ernst and Magritte, the gap is bridged between matter and language, subject and object, signifier and signified, but only in order to set up other paradoxes.

1925. Oil on canvas, 81 x 100 cm. Paris, Private Collection

Fig. 23
Francis Picabia
MI
1929. Gouache on card-
board, 160 x 96 cm.
Whereabouts unknown

Ernst developed the procedure of rubbing over the textured surfaces of objects with pencil (frottage), and adapted it to painting as a technique where layers of paint are partially scraped away to reveal an underpainted surface: this Ernst called 'grattage'. He believed that this technique was in principle no different from collage and wrote of it as a way of intensifying hallucinatory fantasies. Breton also wrote of both frottage and grattage as producing works like the visions seen when half asleep, in which images appear with striking clarity, as though the shadow of the object were 'interrogated', a description which nicely captures the mix of immateriality and correctness in these pictures. For Breton such painting was like striking a coin where the surface retained 'the tangible third dimension of flat objects'. The idea of seeing beyond the accustomed dimensions of an object was important in Surrealism. Grattage was also one response to the problems faced by Surrealist painting, which could not readily be automatist, and which was at the risk of merely copying combinations of banal dream symbols. Grattage was not an automatic procedure, but it was to some extent arbitrary and beyond the control of the artist. The unconscious might be believed to be engaged in the process of reading images into the complex superimposed patterns.

The words of the title are again important here. Just as real objects were altered (for instance, when Man Ray added tacks to an iron) so words or phrases could be transformed. In Breton's article *'Les Mots sans rides'* (1922) words are transformed in order to free them from conventional usage: they are considered as interacting elements whose mutual reactions may be studied as if they were alchemy. Ernst sometimes altered well known trade-names in the titles for his works: *La Belle Jardinière* (1923) refers to a Paris department store; *To the 100,000 Doves (Aux 100,000 colombes)* to a clothing store, *Aux 100,000 chemises.*

In this work the bodies of birds are merged in such a way that while their discreteness is suggested, separation is no longer possible. In this and other pieces, bodies divide up, interpenetrate, turn over and open up: there is a constant confusion and invasion of borders. As in Picabia's 'transparency' pictures (Fig. 23), these works stand as symbols not only of the shifting ground of psychological identity, but also of the undermining of identity as an epistemological concept, and of the subsequent powerlessness of the linguistic world of discrete signs.

17 Blue and Pink Doves

1926. Oil on canvas, 85 x 101 cm. Düsseldorf, Kunstmuseum

Compared with *To the 100,000 Doves*, this picture is very different technically, for the thick, plastery surface of the former has been replaced by light washes which leave much of the canvas bare. This concentration on the painted surface marked a profound change in Ernst's technique, but was an inevitable result of his decision to paint merged and integrated figures. For the critic William Rubin the shallow space, subdued colours and fragmented forms were a reprise of Cubist concerns. It is certainly true that these works are much more conventionally beautiful and better painted than the collage paintings, and Ernst's concern with painterly values allowed their inclusion in Rubin's formalist canon.

Despite Ernst's claim that there was no real difference between collage and grattage, some of the implications of this change in technique were far reaching. Aragon wrote that collage elements could stand in for objects and operate like words: painting thus adopted a literary form, and became like a real language, not merely 'a matter of taste'. Yet in this imagery there is a complicated interplay of object and sign, each threatened with annexation to the other, which is bound up with the erosion of the distinction between subject and object. Who could say what was object, what subject, what thought, what matter, what signified and what did not? With the development of frottage and grattage there can be seen an important shift in Ernst's practice, from the juxtaposition of discrete signifying elements to the representation of complex, indeterminate realms where language fails and flux, resistant to description, rules.

Two Sisters

1926. Oil and frottage with black lead on canvas, 100 x 73 cm. Private Collection

This work is part of a sequence of similar pictures which include *Two Naked Girls* (in two versions) and *Desert Flower*. They use Cubistic devices and muted colours combined with grattage. Emergent and provisional identities are constructed from discrete and weakly connected elements. The way that these figures appear to emerge is a reflection of the process of grattage which is itself experienced as an emergence.

These works and the frottages of the *Histoire Naturelle* (1926) illustrate the futility of systematic knowledge. By using the forms of logical classification against themselves (natural history being the archetypal ordering of living things) Ernst hoped to break their power. Contingency was reinscribed in abstract categories by the reproduction in frottage of fragments of reality. As we have seen, Aragon compared the discrete elements of Ernst's collages to words, but the frottages of the *Histoire Naturelle* are very different, achieving in diverse ways an erosion of classifying boundaries. For instance, waves, wood-grain and the lines made by falling rain are all equated. The surface shared by objects breaks down distinctions and stresses the underlying material. Heterogeneous, hybrid beings, such as the fish/eye in *The Fugitive* (Fig. 24) also appear, these beings not so much constructed from separate members as grown or grafted together. Distinctions are further broken down by the depiction of constant movement, of the shifting and merging of elements. In general, these works represented the natural, pulsating living world, stirring and breaking the classifications imposed by instrumental rationality. They form an image of a world like that envisaged by the theoretician of organic evolution, Jean Baptiste Lamarck, which transcends reduction to classes or species, being a continuum ever transforming in response to milieu, literally through a superposition of form.

Fig. 24
The Fugitive
1925. Black lead pencil,
26.5 x 42.8 cm. Stockholm,
Moderna Museet

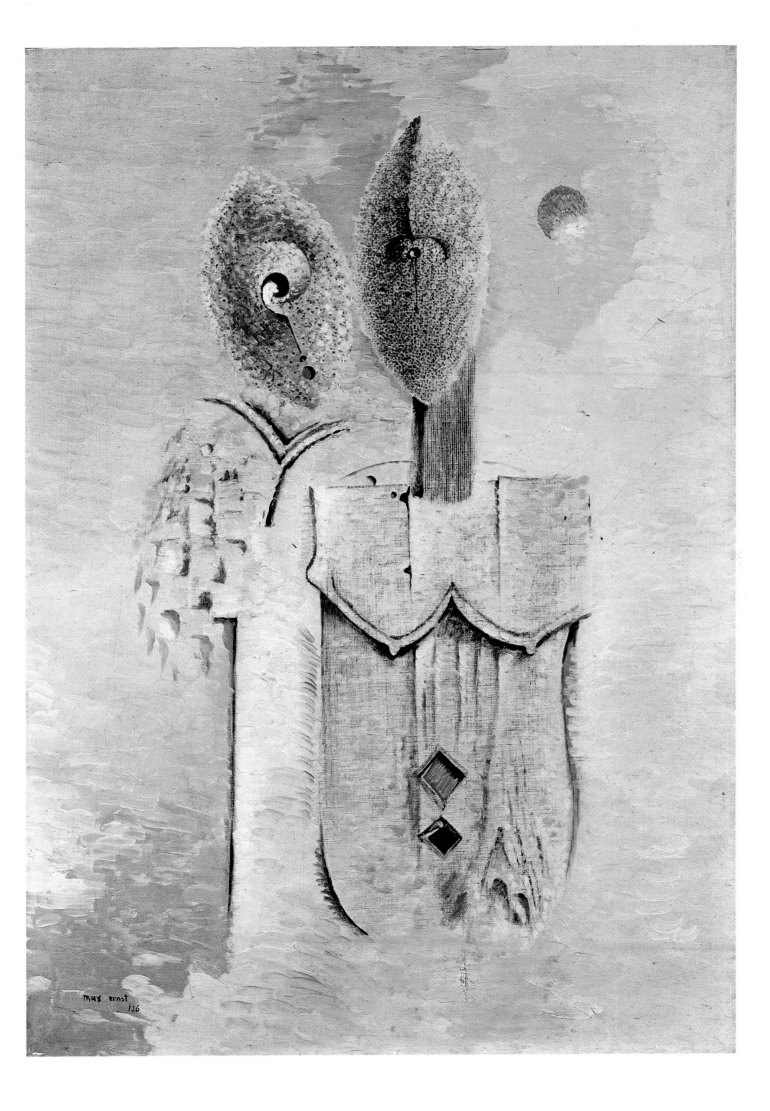

1928. Oil on canvas, 162.5 x 130.5 cm. Geneva, Galerie Krugier

Bodies – some linear, some more solid but roughly modelled – are again merged and disordered here. Tangles of apparently random lines produce vague figures, rather in the manner of André Masson's automatist drawings. We have seen that an anti-classifactory Lamarckianism was a theme in Ernst, and Werner Spies has quoted the German Romantic poet Novalis to similar effect: 'Is not everything full of significance, symmetry, allusion and strange relations?' What is important here is the way a variety of different figures may be read into the forms.

The headless figure was important to Ernst as to other Surrealists. In one sense it was an extension of the concern with blindness, connected to automatism, seen in Ernst's work for *Répétitions* and *Les Malheurs des immortels*, and in his paintings, *Pietà* (Plate 8) and *The Teetering Woman* (Plate 11). The theme is also apparent in the collage novel *The Hundred Headed Woman* (Figs. 9 and 10), where many of the collages deal with the theme of vision. The original title of *The Hundred Headed Woman* (*La Femme 100 têtes*) is a pun on the French, *femme sans tête* ('headless woman') and the theme of headlessness (which stands for a loss of rationality) is a constant factor in the novel. Blindness is only a subset. Blindness is seen as a capability, something which can lead to inner vision. Headlessness is a more extreme version of the same theme, in which the offending organ of rationality is entirely removed, leading the emotive and instinctive lower body in control.

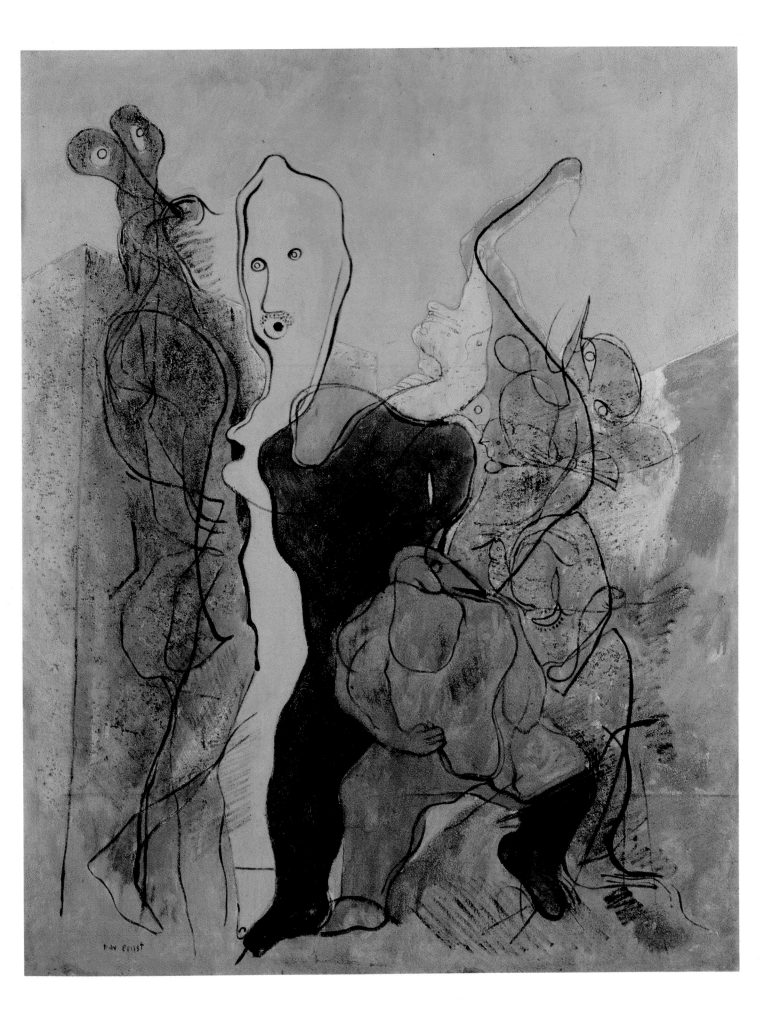

Monument to the Birds

1927. Oil on canvas, 162.5 x 130 cm. Paris, Private Collection

Fig. 25
René Magritte
Pleasure
1926. Oil on canvas,
74 x 98 cm. Düsseldorf,
Nordrhein-Westfalen
Collection

This work and others similar to it make up an ironic form of avian apotheosis. There is perhaps a mocking reference here to Baroque ceiling paintings representing subjects such as the Ascension. For Freud, writing of Leonardo, flight meant 'nothing else in a dream but a longing to possess sexual prowess', and Breton was later to pick up this association in writing of Ernst's 'Loplop' works.

Works in this style represent a break with collage-based painting, for while the forms of the bird-emblem have been fabricated and assembled, there is little sense of the heterogeneity of the parts, but rather of a tight integration of form. Birds were undoubtedly part of Ernst's personal iconography, but they also had a much wider reference within Surrealism, being one of its most widely used visual subjects. A frequent metaphor for gaining access to the Beyond (see Plate 10) was some perception of or movement in the fourth dimension. While the fourth dimension is now considered a mere mathematical construct, in the 1920s many believed it to have some physical and spiritual existence to which access might be gained: the most common metaphor for explaining the fourth dimension involved comparisons with beings that move in two dimensions with those that move in three. It may be that the Surrealist obsession with birds and fishes is in part to do with these animals' greater latitude of movement, which is not confined to two-dimensional surfaces. In the work of Ernst and other Surrealists, particularly Yves Tanguy, there is an equation of submarine movement and flight. In general, the prevalence of the theme of weightlessness in Surrealist painting reinforces this notion of four-dimensional freedom, a freedom easily connected with Freud's linking of flight in dreams and the erotic urge. A link was established in general terms between the infinite, flight, the fourth dimension and spirituality. While in *Monument to the Birds* all is well, the frequent theme of the assault and demise of birds in Surrealist painting is a metaphor for the attack on the fourth dimension, and thus upon the spirit. Examples include André Masson's *Bird Pierced by Arrow* (1925), Joan Miró's *Personnage Throwing a Stone at a Bird* (1926), and René Magritte's *Pleasure* (Fig. 25).

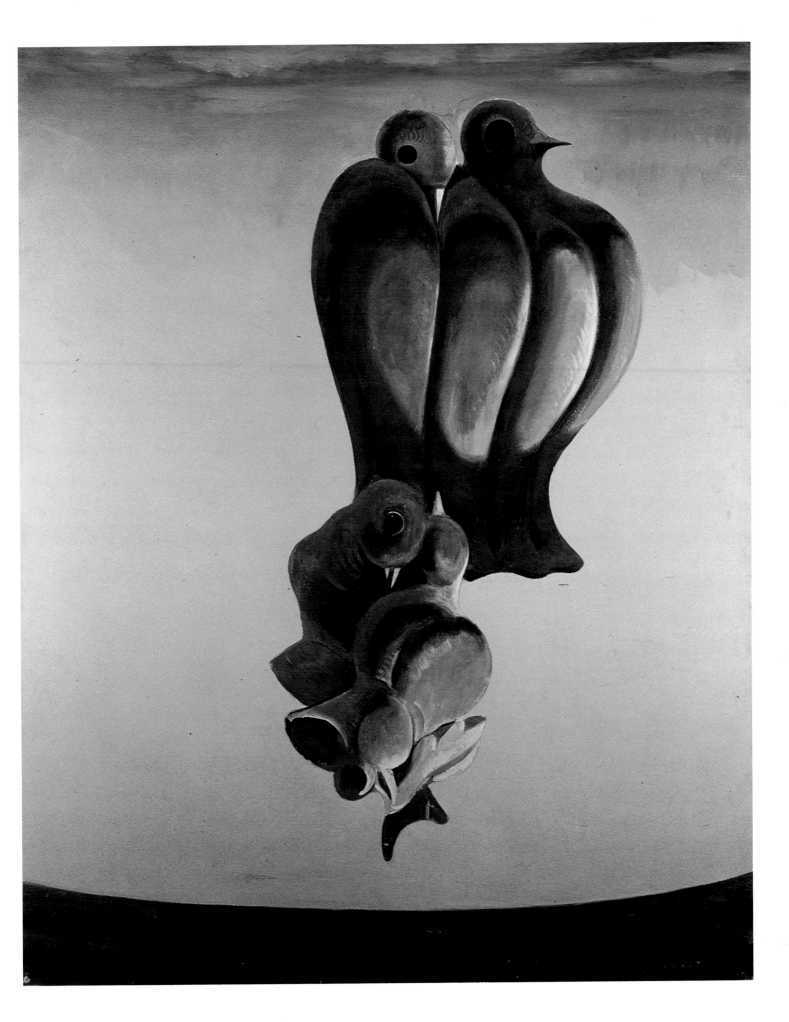

On the Inside of Sight: The Egg

1929. Oil on canvas, 98.5 x 79.4 cm. Private Collection

This work is one of a sequence begun in 1928. It is a development of the emblematic and even heraldic imagery of *Monument to the Birds* (Plate 20). It is based on a carved relief in the collection of the British Museum and shows an integrated bird family, or trinity. Compared to the works which precede and follow them, this series of paintings are light and even witty. Looking at these birds holding eggs in their beaks while themselves contained within an oval (egg) shape, it is difficult not to think of chicken-and-egg dilemmas. Such paradoxes are not entirely irrelevant: they may become another point of access in the picture beyond conventional vision and logic. At each corner of the painting appear chimerical figures, hybrids of flora and fauna, Baroque devices which appear to be in the process of metamorphosis. These intermediate creatures have been seen as an allegory of the ambiguous nature of Surrealist visual practice, but they must surely have a broader reference than this, crossing boundaries between what is real and what is represented, between male and female, animal and vegetable, and undermining common notions of identity and causality as they do so. The creatures inside the egg form are very clearly delineated, but since the lines sometimes overlap, it is difficult to be sure where one bird ends and another begins, or whether any particular element belongs to more than one of them.

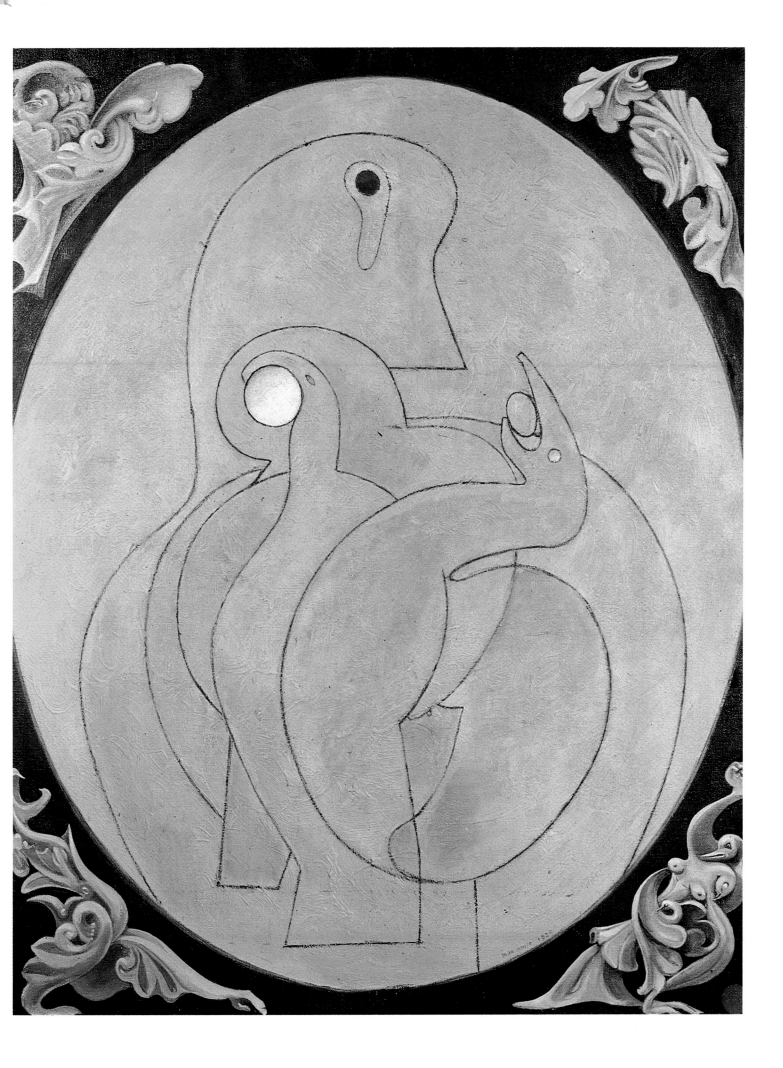

Snow Flowers

1929. Oil on canvas, 130 x 130 cm. Belgium, Private Collection

74

Ernst made a number of flower pictures at this time, and in some ways these pretty paintings present a puzzle within his *oeuvre*. Light, translucent colour is thinly applied with a knife over a dark ground and the resulting interpenetration of glazes creates forms which may be read as biological or inorganic, as much like shells or fossils as flowers. Indeed the snow flower pieces develop out of grattages which Ernst made of fossil ammonites in 1928. Even in these attractive pieces indeterminacy and transformation are thus still themes. A more familiar piece of iconography appears at the bottom right of this work – birds like those in *On the Inside of Sight* (Plate 21), caged within a little square. A landscape is suggested by the sharp lines forming a horizon and dividing the ground, and by the round planet-like object which floats in the sky. It is as though we are witnessing some nocturnal, perhaps primeval, scene of growth and transformation. The flowers are connected by dull-coloured bands rather in the way that hats are joined together in *The Hat Makes the Man*, and begin tentatively to form figures. The flowers themselves fold and unfold, creating different, always provisional combinations of shapes. Given the presence of the caged birds, it is difficult to argue that this painting should be read as entirely positive. It may be that we are meant to recognize an opposition between the fluidity of the flowers and the ordering force of the connecting strips, as if this was a representation of the dialectical conflict between words and things, objects and representations.

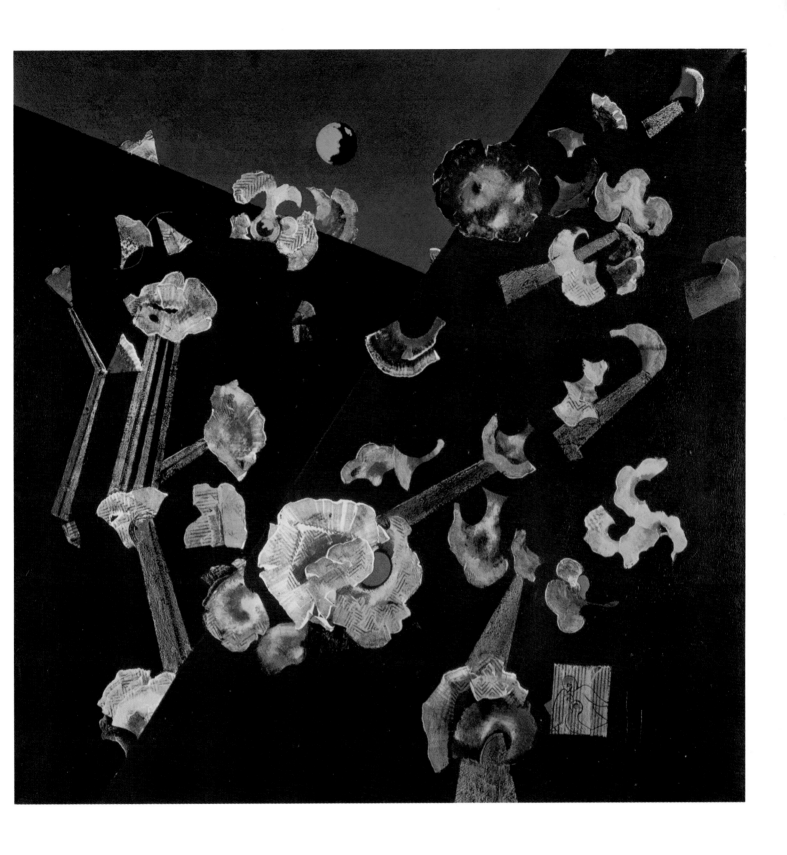

Cheval the Postman

1929-30. Collage, 64 x 48 cm. New York, Solomon R. Guggenheim Museum

The postman of the title was Ferdinand Cheval of Hauterives (1879-1912) who built his own fantastical, Orientalist palace from stones and shells and decorated it with sculptures and odd inscriptions. His dream was to build a fairy palace out of 'primitive' times. The building was often visited from 1929 by the Surrealists, attracted by the product of an untutored naive, much like the work of the Douanier Rousseau.

Some of the attributes of the postman naturally appear among the great variety of material here: the postcard and windowed envelope alongside the appliqué embroidered silk tie at the 'neck' of the figure, and the end-papers from books and printed matter, are all combined with painting and drawing. The figure also forms an easel on which some of the elements of the picture are presented, an internal display which further distances the viewer from the work. Some of the elements are old-fashioned, and this relates to the Surrealist attraction to the outmoded. Cheval's *Palais Idéal* itself was a curious mix of the overstuffed detail of nineteenth-century decoration and a primitive urge to imitate the organic. Its alternation of detailed and smooth passages is curiously reminiscent of Ernst's later use of decalcomania. The radical idea that this paltry collection of rather ragged mementos can compose a portrait is based on the reference of the archaic nature of some of the material to memory, and its diversity to a heterogeneous and unintegrated personality divided into separate layers, like the collage itself.

1927. Oil on canvas, 115 x 146 cm. Amsterdam, Stedelijk Museum

Fig. 26
André Breton
Un Chevalier
1926-7. Sand, gesso, panel
and charcoal on canvas.
Private Collection

The primal horde represented here probably refers to Freud's *Totem and Taboo*, in which a murderous Oedipal rebellion is staged by children against their father. Again there is much merging of figures, which stresses the collective identity of the horde, and a mixing of human and animal forms. However, an opposition is established between the volatility of the figures' identities, the violence of their gestures and the fixity of their apparent fossilization. Ernst has contrived not to show us the horde itself, but to make us very much aware that what we see is a reading of our primal past into the fixed forms of the present.

In the grattage method Ernst used a trowel to scrape away paint so as to reveal the forms of real objects that he had placed under the canvas. In this method, paint can become like plaster, the canvas a wall bearing the imprint of objects behind it. Such a practice attempted to side-step problems associated with conscious representation, by making the object more palpably present, by letting it leave an actual trace on the work, as if in a painterly photogram.

In this work twine soaked in paint has been dropped onto the canvas to create randomly curved lines which have then been used as a basis for representation. This adds another layer of arbitrariness to the process, which was also used by other artists. For instance, Marcel Duchamp dropped pieces of string onto canvas and presented their chance configurations as works of art in *Three Standard Stoppages*, reusing the lines obtained in other works, including *The Large Glass* (or *The Bride stripped bare by her bachelors, Even*). André Masson employed a similar technique, dripping glue onto the canvas and then pouring sand over it, in paintings like *Un Chevalier* (Fig. 26).

The Great Forest

1927. Oil on canvas, 114 x 146 cm. Basle, Kunstmuseum

At one level, the subject of the forest, on which Ernst often worked, was a thematic cliché which made reference to German Romantic painting, especially that of Caspar David Friedrich. Yet it could also be taken seriously as a complex, disorienting and forbidding realm, a labyrinth and a possible prison. The bird within *The Great Forest* is both partially hidden and trapped – and there is a link between these two states in psychoanalytic terms, where it is revelation of the hidden which leads the way out of neurosis.

While Romantic symbolism idealizes and transfigures its subjects, here Ernst comes closer to allegory. As in *The Horde* the forms here appear both primordial and petrified. This, with the baleful ring in the dark sky, suggests a scene of mass extinction following some apocalyptic event. It has been proposed that the ring in the sky may represent an eclipse of the sun, in an image which thus unites sun and moon, as if they were alchemically joined.

In *Showing the Head of her Father to a Young Girl* (Fig. 27), Ernst has posed a dramatic scene against the backdrop of the forest. The dead forest reflects the blank faces of the protagonists. In his book about Charles Baudelaire, the nineteenth-century poet and critic, Walter Benjamin wrote of the decline of aesthetic aura, that is, of the power works of art used to have to impress upon the viewer a sense of their presence, where we come across 'eyes of which one is inclined to say that they have lost their ability to look'. The Surrealists were much concerned with the faceless, modern manufactured person, and it may be that in presenting the viewer with blank images of tragedy and apocalypse, Ernst demonstrated our inability to return the gaze.

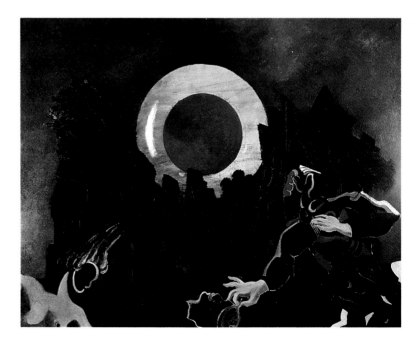

Fig. 27
Showing the Head
of her Father to a
Young Girl
1926. Oil on canvas,
65.5 x 81.5 cm.
Private Collection

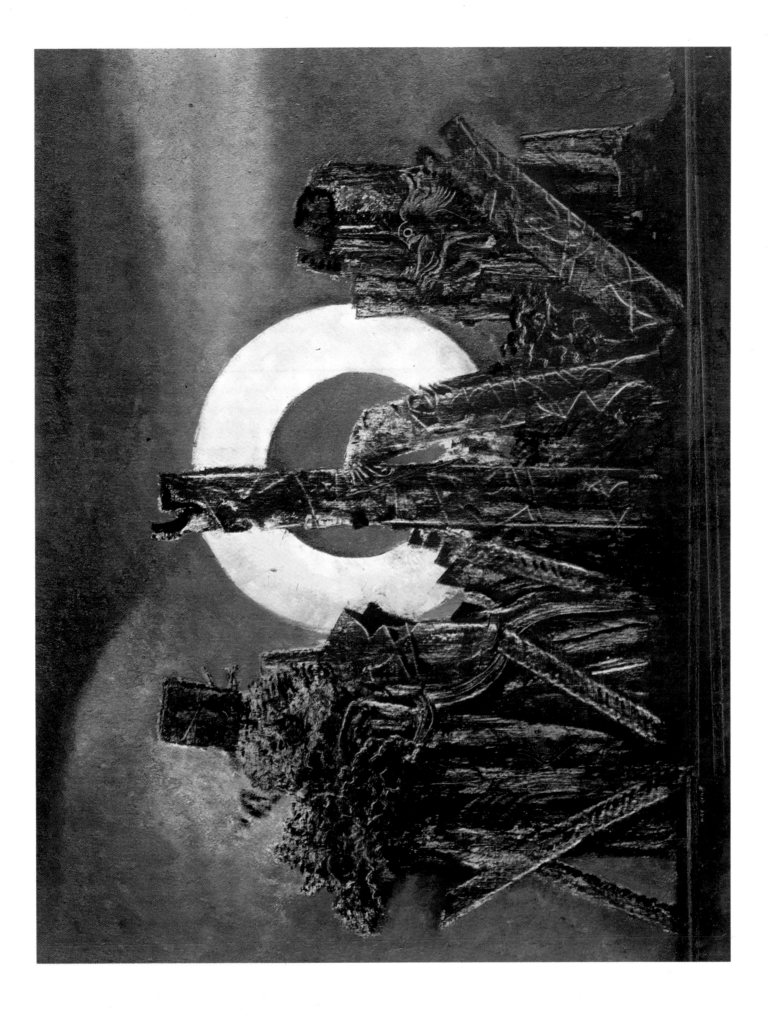

Edge of a Forest

1927. Oil on canvas, 38 x 46 cm. Bonn, Stadtische Kunstsammlung

This is another variation on the forest theme, with a thick, plastery surface with indentations, in which the trees take on the form of combs. Ernst was quite clear that these works should not be viewed as the production of a talented artist subject to the vagaries of inspiration. In 1934 he wrote that '... every normal human being (and not merely the 'artist') has an inexhaustible store of buried images in his subconscious, it is merely a matter of courage or liberating procedures ... of voyages into the unconscious, to bring pure and unadulterated found objects to light ...' There is some suggestion here that the contents of the subconscious may be shared between individuals, that in looking on the products of Ernst's 'voyages', we will find something that speaks to our own buried images. Given these assumptions, indeed, it is only with the operation of a collective unconscious of the kind described in the psychoanalytic theories of Karl Jung (in which Ernst was very interested), where images have power because they invoke in all of us unconscious memories of our primeval past, that such pictures will have any force. Despite its Romantic connotations, the forest provided Ernst with just such a primal image, which might achieve universal significance.

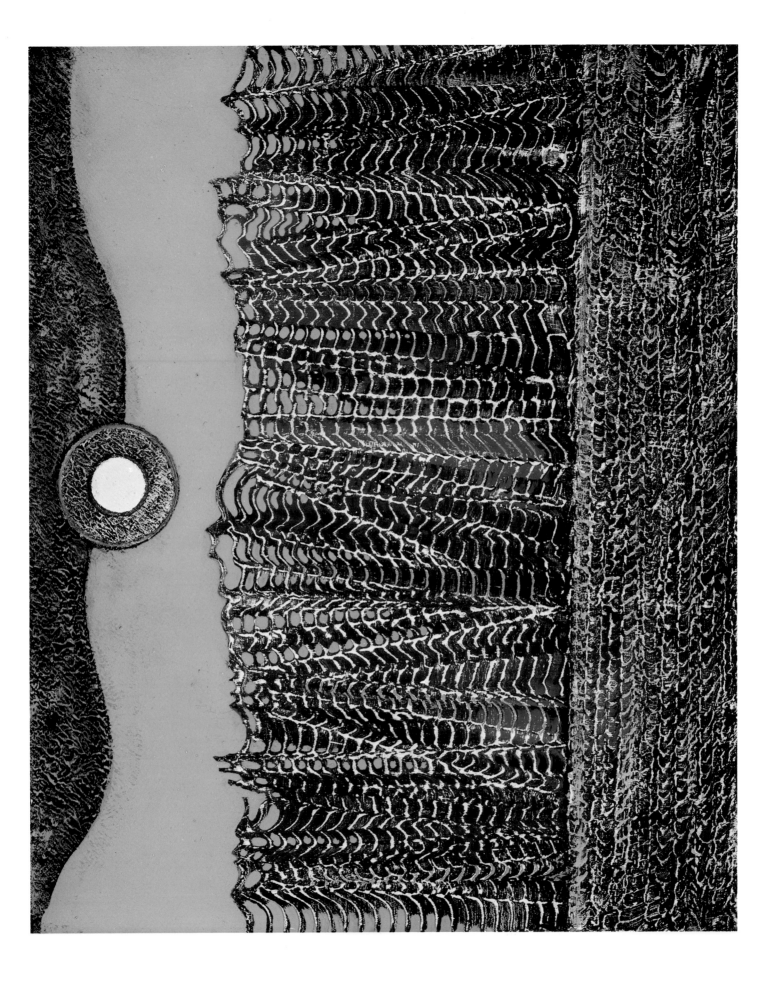

1927. Oil on canvas, 162 x 130 cm. Paris, Private Collection

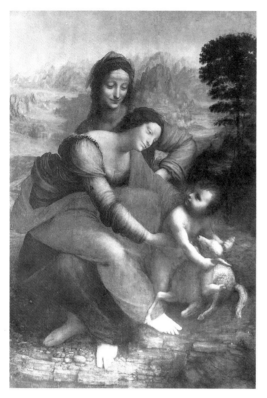

Fig. 28
Leonardo da Vinci
The Virgin and Child
with Saint Anne
1510-12. Oil on wood,
170 x 129 cm. Paris,
Musée du Louvre

One Night of Love is atypical of Ernst's work both in formal terms – its colouration and the combination of lines and flat colour – and in its unremitting negativity in dealing with a subject which the Surrealists usually gave sympathetic treatment. 'Mad love' and sexual passion were generally seen by the Surrealists as a route to the Beyond (indeed in 1931 Ernst himself wrote a libertarian attack on the regulation of the erotic) yet here it is represented as a matter of violence, domination and even dismemberment. Once again bodies are only provisionally human, the upright figure appears to have a bull's head and birds seem to emerge out of the lines which make up the larger figures. The hierarchy of the body is radically ruptured, with limbs displaced and heads hollowed out or split in two.

This work has been seen as a transformation of Leonardo da Vinci's *The Virgin and Child with St Anne* (Fig. 28), and there may be some formal relation between the compositions. The point behind the comparison is the combination of birds and bodies which may refer to Oskar Pfister's 'discovery' of a vulture hidden in the forms of Leonardo's work, an idea which was used by Freud in an analysis of the painter's psycho-sexual drives (an interpretation which has since been shown to be based on a mistranslation). The relation between Freud's analysis, the Leonardo painting and *One Night of Love*, if there is one, remains obscure.

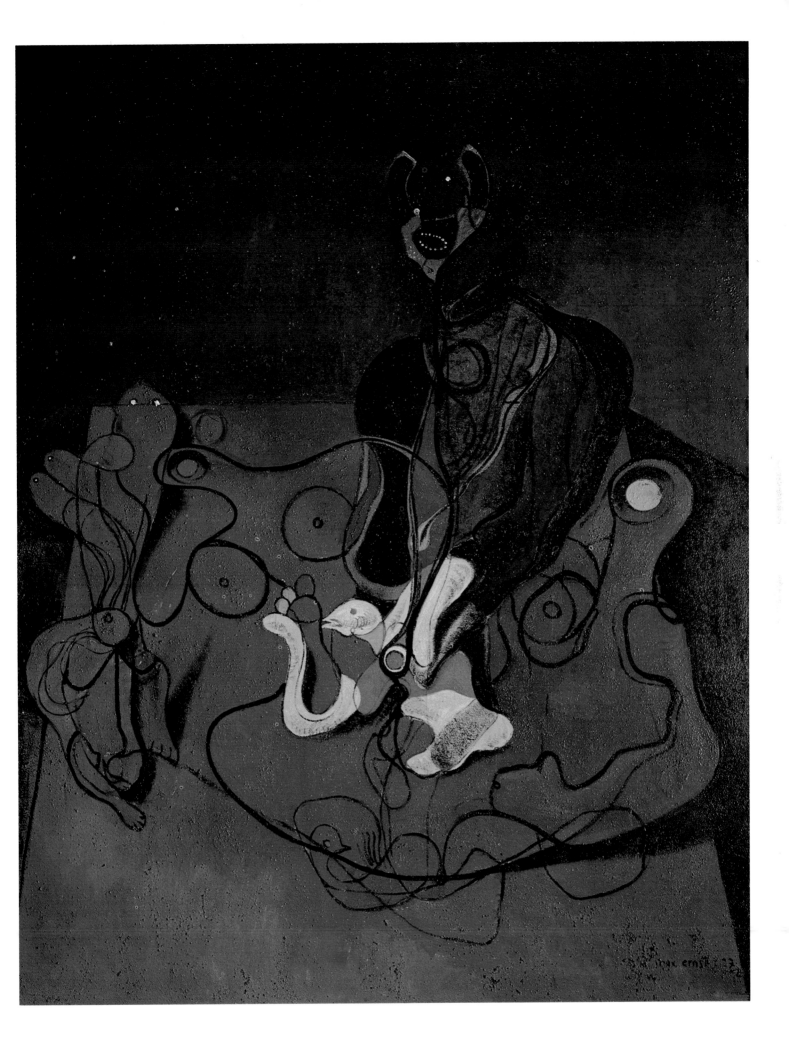

1934. Oil on canvas, 93 x 77 cm. Collection of Mr and Mrs Julien Levy

Sexual and aesthetic issues are bound up in the *Blind Swimmer*, for not only does it represent the fertilizing seed but also the pioneering, automatic artist. The anatomical and sexual connotations of the picture are made quite explicit. Two works of this name were made in 1934: in the other the lines are more regular and centre on the quite specific image of a seed, clearly showing both its external casing and internal food supply. The version illustrated here is much fleshier, suggesting the inside of a body, comprising an internal passage, and the element on the left which is probably meant to be read as a sperm. Such a reading is certainly supported by the title, since 'the effect of contact' may take on a sexual meaning. The source for the picture has been identified as a plate from a scientific textbook showing galvanic currents: electrical and sexual energy were often linked by Ernst. This identification plainly derives from Freud's notion of pansexualism in which all mental force is a product of sexual drives. The two are also linked in another way, for it is in the momentary uniting of opposite principles that knowledge of the Beyond is unconsciously produced.

In *Beyond Painting*, Ernst wrote about frottage and its relationship to automatism: 'The author is present at the birth of his work as an indifferent or passionate spectator and observes the phases of its development ... the painter's role is to outline and *project* what is visible within him ... I have done everything to *make my soul monstrous*. Blind swimmer, I have made myself a seer. *I have seen*. And I caught myself falling in love with what *I saw* and wanting to identify myself with it.' The automatic artist is thus a bystander at the fertile union of opposing principles in painting.

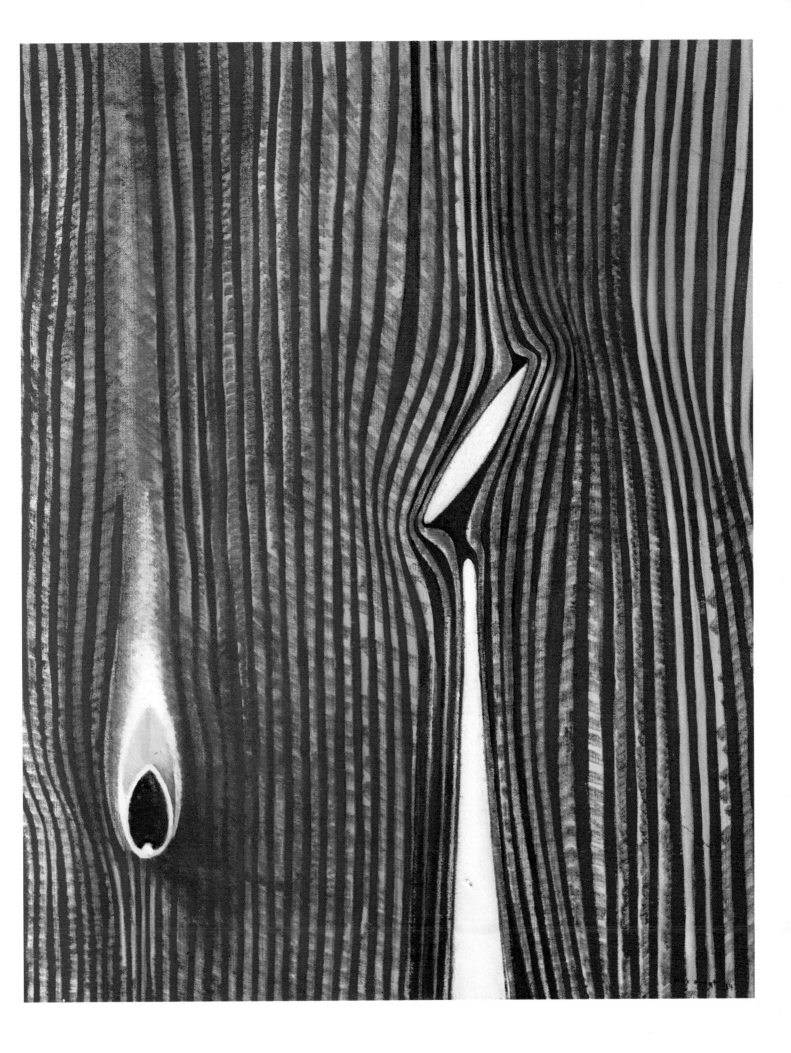

Loplop Presents

1931. Collage and pencil, 64.5 x 50 cm. London, Private Collection

This is one of the large-format collages which Ernst made in the early 1930s. They are quite distinct from the earlier collages since they were made not for reproduction but for sale as unique works. They make no attempt to disguise the diversity of materials used within them, nor to cover up the joins, which are instead presented as a feature. They come closer to Cubist collage, which also employed a variety of surfaces, often distributed sparsely against a neutral background. In fact there was a gap in Ernst's collage production from 1922 until 1929, and when he resumed it was in two quite different modes: these single, fine art works, and the serial collages of the novel *The Hundred Headed Woman*, where the variety of sources and the process of collage are carefully concealed.

In addition, it is in these collages that Ernst's manufactured alter-ego, the bird Loplop, appears. In this scene Loplop presents the work to the viewer (his head appears towards the top of the picture) and as in *Cheval the Postman* (Plate 23) its figure can also be read as an easel. In Ernst's fabricated psychobiography, Loplop takes the position of totem, something Ernst described as a 'private phantom', an animal familiar, using well-known anthropological sources (J.G. Frazer and Lucien Lévy-Bruhl). The totem is also a clan animal and, as we have seen, the bird would also be an appropriate emblem to stand for Surrealism as a whole. The theme of this work appears to be art itself, with its geometric construction lines and the reference to the knowledge of anatomy needed for life drawing. There is a possible linking of traditional representation with penetrating, instrumental knowledge.

Garden Aeroplane-Trap

1935. Oil on canvas, 54 x 73.7 cm. Paris, Centre Georges Pompidou, Musée National d'Art Moderne

Between the late 1920s and the early 1930s Ernst's work became less solemn, more playful and more self-referential. Economic and political events were to change this mood radically, particularly the rise of Fascism in Germany and the renewed threat of war. Ernst began to return to themes which he had dealt with fifteen years earlier. This painting is one of a series of five *Garden Aeroplane-Traps* made between 1935 and 1937. Whereas in *The Massacre of the Innocents* (Plate 6), the aeroplanes are the aggressors, here, according to Ernst, 'voracious gardens [are] devoured by a vegetation springing from the debris of trapped airplanes'. John Russell has pointed out that the flowers may be either trophies or wreaths, and the forms of the painting are deeply ambiguous about which forms are traps and which the trapped, an ambiguity which is also apparent in Ernst's description of the works. Even the forms of what appear to be the planes have an organic feel, as though made of bone or some rubbery leaf matter. Indeed it may be that we should read these forms not as aeroplanes but as lures, outgrowths of the plants themselves which mimic the form of their enemies. In any case, in this Surrealist fantasy a carnivorous, vegetable nature appears to take its revenge on technology.

The Whole City

1935-6. Oil on canvas, 60 x 81 cm. Zurich, Kunsthaus

92

This work is one of a series of petrified or entire cities, executed between 1933 and 1936. Decorative relief blocks used in textile printing were used to make the patterns which were then detailed and worked over with the brush. As with the forest pictures, there were Romantic precursors for this type of image, including the work of Friedrich and also Victor Hugo's drawings of his journey down the Rhine, which Ernst had seen and admired.

The image is of a lifeless city encroached on by nature. Its stepped form is reminiscent of ancient cities in South America. Again the threat of war may lie behind these representations, although they remain equivocal. On one hand, the image of an overgrown technology was much used by the Surrealists as a symbol of the final dominance of nature and emotion over civilization and reason. The choice of the city for such treatment referred directly to the technocratic urbanist utopias of the 1920s (such as Le Corbusier's Plan Voisin), plans laid to ruins by the Great Depression a decade later, and then by the threat of renewed war. On the other hand, the gloomy image may reflect Ernst's realization that not all forces opposed to rationality and committed to the violent overthrow of the established order were amenable to Surrealism.

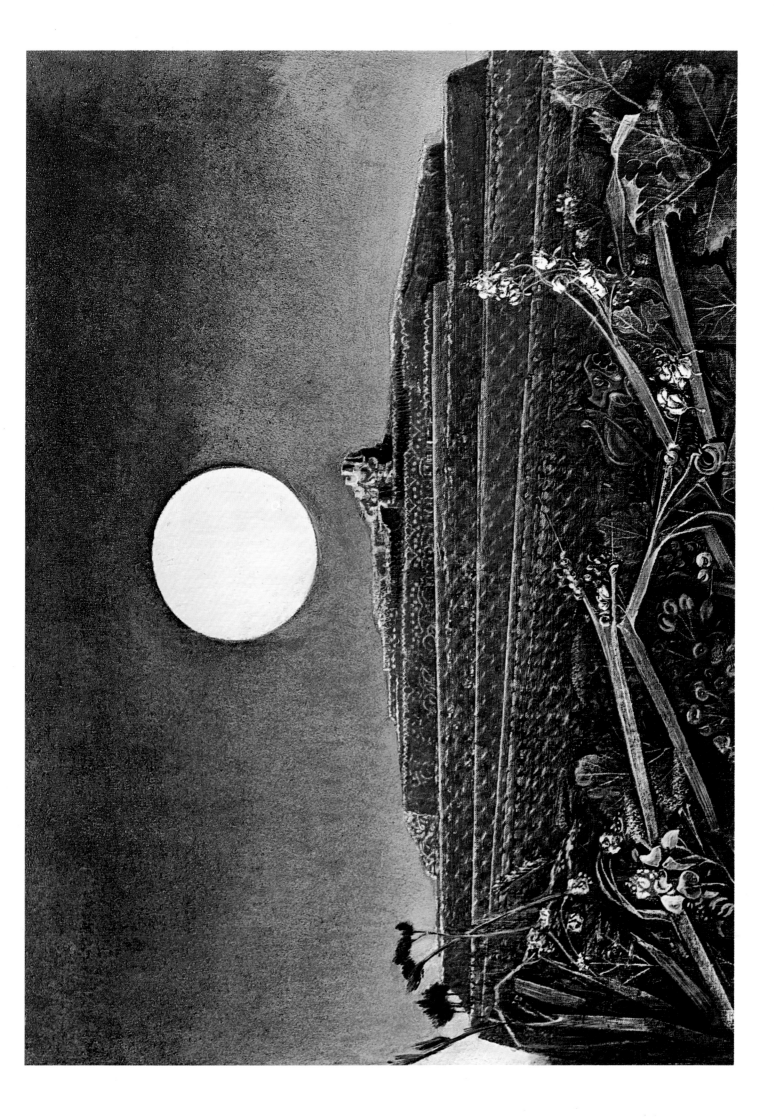

1936-7. Oil on canvas, 60 x 73 cm. Staatsgalerie Moderner Kunst, Munich.

This is a reprise of Ernst's early enthusiasm for the painting of the 'Douanier' Rousseau whose works he had seen at the Sonderbund exhibition in Cologne in 1912 (Fig. 29). While Rousseau's forests seem more ordered and the forms within them more discrete, there is still a great similarity not only in the format and the view of the jungle, but also in the violence committed within it, and the blithe unconcern of the surrounding beings.

Ernst's jungle is a profusion of luxuriant, over-verdant vegetation, of fertile plant forms, bursting and spilling, which either predates or has swamped civilization. The humans in this jungle are certainly powerless against its stupefying effects. Out of this vegetation emerge various animals, including mantis-like creatures which Ernst identified as female dragonflies devouring their partners during the sexual act. All are to a degree merged with the jungle, while parts of the plants take on animal characteristics. In 1938, the poet Benjamin Péret described such a process in the journal *Minotaure*, in an article called '*La Nature dévore le progrès et le dépasse*', and in 1934 Ernst had written an article on 'The Mysteries of the Forest' which was illustrated with close-ups of trunks and branches. The whole adds up to an image of claustrophobic complexity, emphasized by the high horizon, and of an unconscious, unheeding violence.

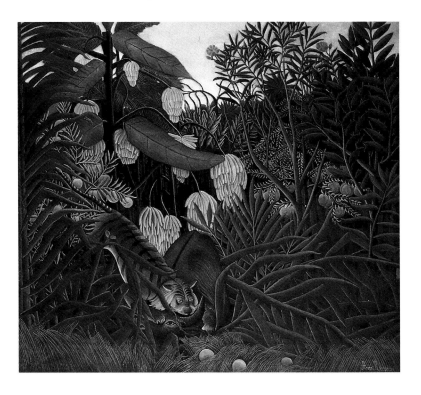

Fig. 29
Henri Rousseau
The Jungle: Tiger
Attacking a Buffalo
1908. Oil on canvas, 172 x
191.5 cm. Cleveland,
Museum of Art

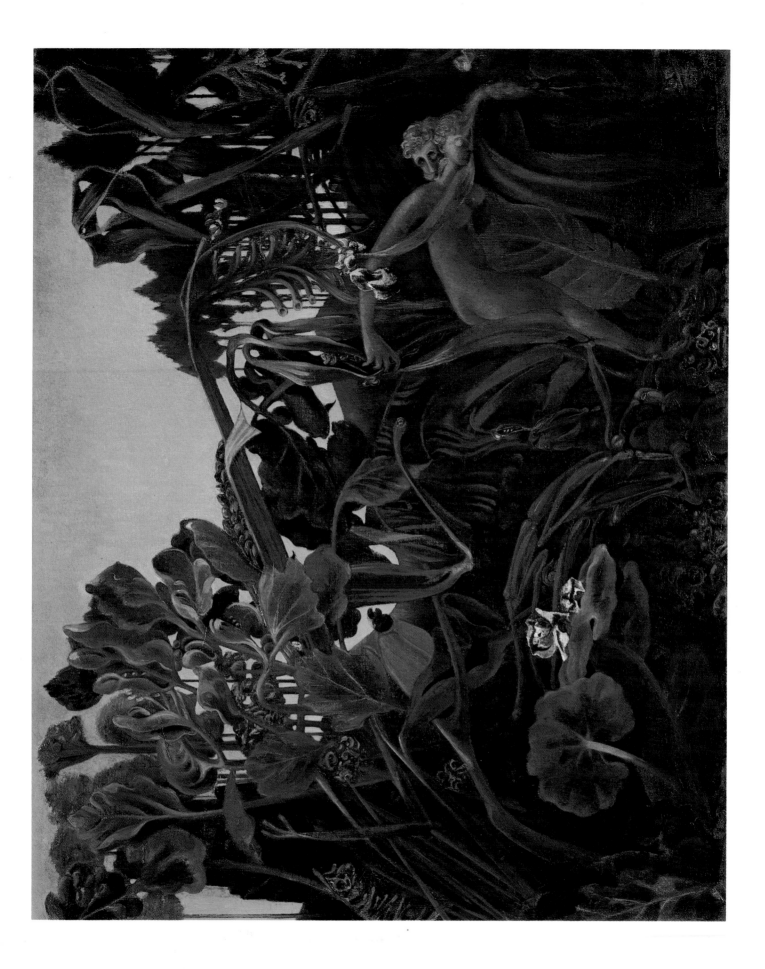

1937. Oil on canvas, 114 x 146 cm. Paris, Private Collection

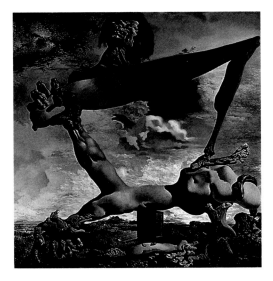

Fig. 30
Salvador Dali
Soft Construction
with Boiled Beans:
Premonition of
Civil War
1936. Oil on canvas,
99 x 99 cm. Philadelphia
Museum of Art, The
Louise and Walter
Arensberg Collection

This is one of the few works for which Ernst gave an unequivocal explanation, albeit with hindsight: 'One painting I did after the defeat of the Republicans in Spain was *The Angel of Hearth and Home*. Now this was naturally an ironic title for a sort of ungainly beast that tramples down and destroys everything in its path. It was the impression I had at the time of what was likely to happen in the world, and I was right.' Other artists of course also made explicit works about this theme, including Picasso's *Guernica* and, from a different and more ironical perspective, Salvador Dalí's *Premonition of War* (Fig. 30). Hearth and home were of course virtues expounded by the Fascists, yet this creature is far from domesticated, with its animal features, claws, beak, horse's hoof and reptilian adjuncts. In an earlier version of the painting, the green avian or dinosaur-like figure at bottom left was separate and might be thought to be trying to hold back the monstrous angel: it could even be identified as Loplop. In this version, its absorption into the main figure merges once antagonistic forces in a single organism.

The painting's former title (when it was shown at the International Surrealist Exhibition in 1938), *The Triumph of Surrealism*, has been read as a satirical comment on the powerlessness of the movement in the light of the success of Fascism. It may be that it had a more serious intent. Just as Freud held that repression was at once a malevolent inhibition of natural instincts leading to illness, and a mechanism necessary for the continued operation of civilization, so the Surrealists, whose recommendations for the release of the unconscious from rationality had often been violent, were now confronted by the spectacle of a destructive, apparently instinctual and mythically-based force roaming the plains of Europe.

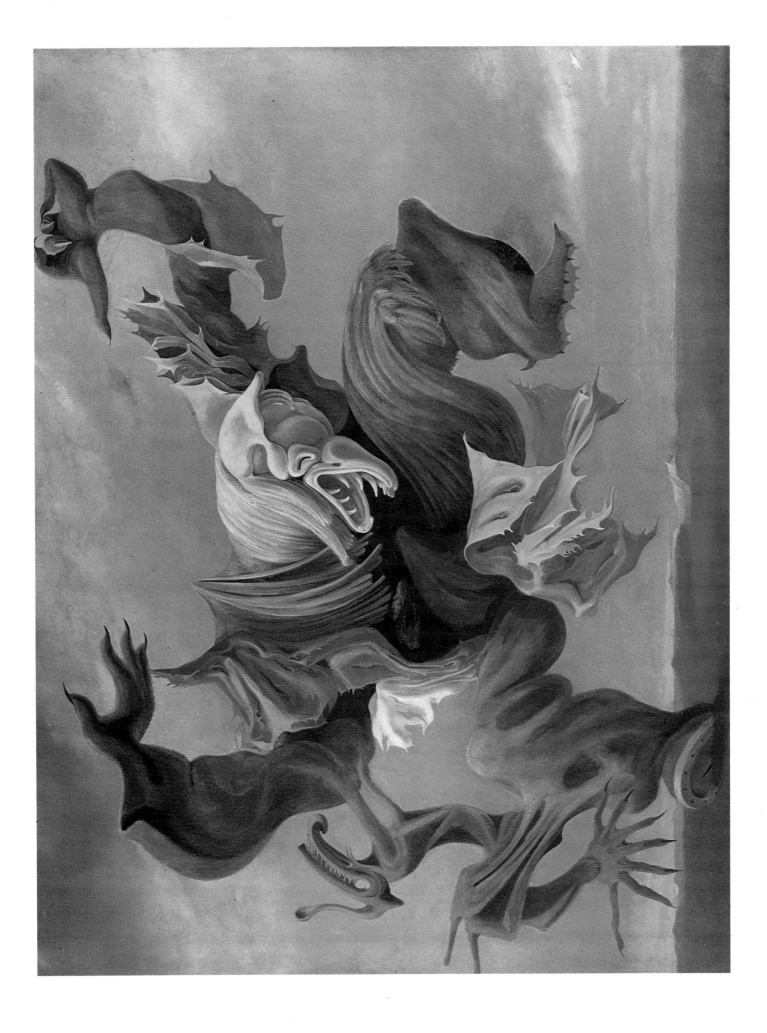

1939. Oil on canvas, 130 x 96 cm. Venice, Collection of Peggy Guggenheim

A definitive break in Ernst's work is marked by this picture, which unites the combination of detailed and separate elements seen earlier in the collages with a highly illusionistic style. The arrow piercing the bride's robe echoes that penetrating the walnut in *Oedipus Rex* (Plate 9) and signals this change in direction. According to Breton, one of the conditions of Surrealist 'convulsive beauty' was the 'expiration of movement'. Of the examples Breton gives, one is of a locomotive overgrown in the forest (a motif clearly sympathetic to Ernst), the other of a Hawaian chieftain's mantle made of thousands of red feathers. The cloak of the bride has its source in rock forms seen by Ernst on a visit to stalactite caves in southwestern France. In *L'Amour Fou*, Breton wrote of a cloak of stone in a grotto 'whose drapery will forever challenge the sculptor and which the illumination of the spotlight covers with roses so that he may never have reason to envy this splendid and convulsive mantle, which was created by the infinite repetition of the unique, tiny red feather of a rare bird which used to be worn by the ancient chiefs of Hawaii.'

As with the earlier paintings the meaning of this work is far from clear, although, as David Hopkins has pointed out, it bears clear references to Duchamp's *The Large Glass*, and may be in some sense a response to it. Hopkins has also explored the iconography of the work as it relates to Rosicrucian and alchemical texts, in which the robing of the bride is a prelude to marriage, and to Duchamp's later stripping. The stork is a symbol of fertility and the broken arrow a familiar phallic symbol. Ernst's interest in ambiguous or merged sexual identity, already noted in *Men Shall Know Nothing Of This*, is evident in the hermaphroditic homunculus at the bottom right. Again the significance of alchemy for Ernst was in its function as an alogical sign system, where as in criticism identities constantly shift, and where an end to interpretation, while offered, is forever deferred.

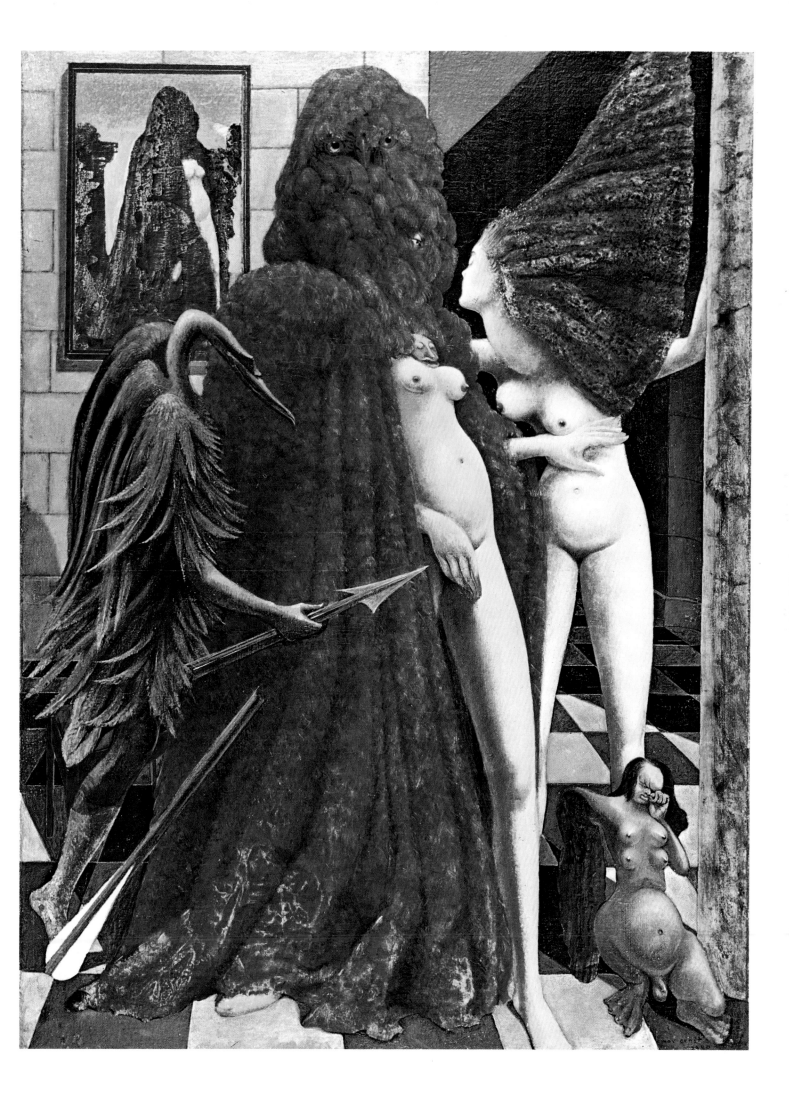

Napoleon in the Wilderness

1941. Oil on canvas, 46.3 x 38.1 cm. New York, Museum of Modern Art

Another shift in direction for Ernst was in part founded on a new technique which exploited chance: in decalcomania a sheet of paper or glass is placed on the paint surface and then pulled away. Oscar Dominguez first used the technique with gouache and Ernst adapted it for use with oils. It produced the effect of an intense and, as it were, normally unrepresentable detail in which forms also seemed indeterminate, and into which the viewer may read a variety of things. Breton, writing of Dominguez, called it a parody of 'human endeavour (representation and comprehension)'.

Only parts of this work were formed by decalcomania (the pole and the ground, for instance), the rest being brushed in conventionally in a highly detailed, naturalistic style which recalls the complex but fantastic paintings of Gustave Moreau. Such works were certainly a departure for Ernst, but the interest in the substratum of natural forms and in the borderline between the biological and the geological is still current. In this painting a Napoleonic figure apppears, with a totem pole and a partly overgrown female holding a strange wind instrument. Napoleon is placed in a voyeuristic position with regard to the partially naked woman, and the erect totem between the two takes on sexual connotations, although Napoleon's gender in this work is also ambiguous. Napoleon, an exiled dictator, refers in complex ways to Ernst's predicament of wartime flight, and to the war itself. The female figure appears part calcified, like Lot's Wife, reduced to a pillar of salt, which introduces another layer of reference to the mass destruction taking place in Europe.

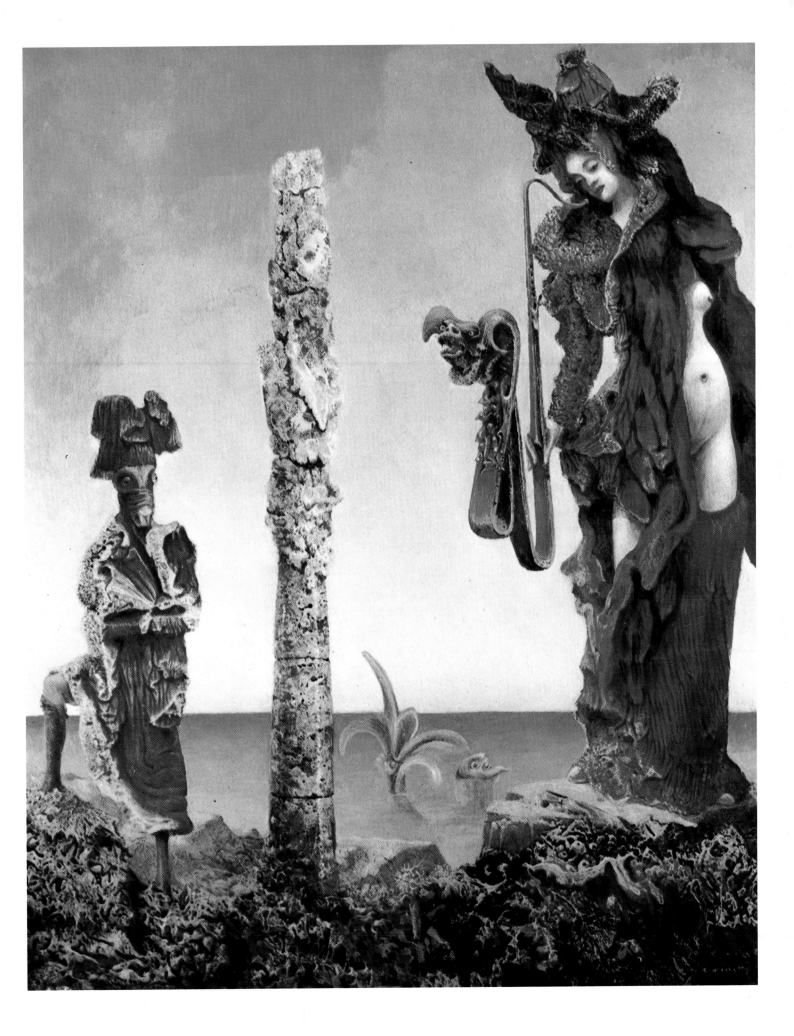

Europe After the Rain II

1940-42. Oil on canvas, 55 x 148 cm. Hartford, Connecticut, Wadsworth Atheneum

This apocalyptic work was made while Ernst was still in Europe, and was sent by post to the United States. It clearly shows an image of the aftermath of war, composed of corpses and decayed vegetable and mineral matter, and inhabited by two warlike figures. Birds, bird-headed humans and other indeterminate creatures are hung or stand petrified around the scene, while an armoured bull lies submerged in the flotsam. The ruined architectural structures are encrusted and overgrown. This is a nightmare version of the Surrealist hope that nature would swallow civilization, and of Breton's image of the locomotive smothered by the forest.

Ernst had made another painting with the same title in 1933 (Fig. 31), the year Hitler came to power in Germany: this shows a form which bears some resemblance to a map of Europe fallen into ruin and decay. The clearly political nature of the work led to Ernst being blacklisted by the Nazis. While its tone is certainly negative, this painting may also be reminder of the more ambiguous ruined cities Ernst had imagined, or of the Surrealist map of the world which shrunk Europe to insignificance.

Fig. 31
Europe After the
Rain I
1933. Oil and plaster on
panel, 100 x 148 cm.
Zurich, Carola-Giedion-
Welcker

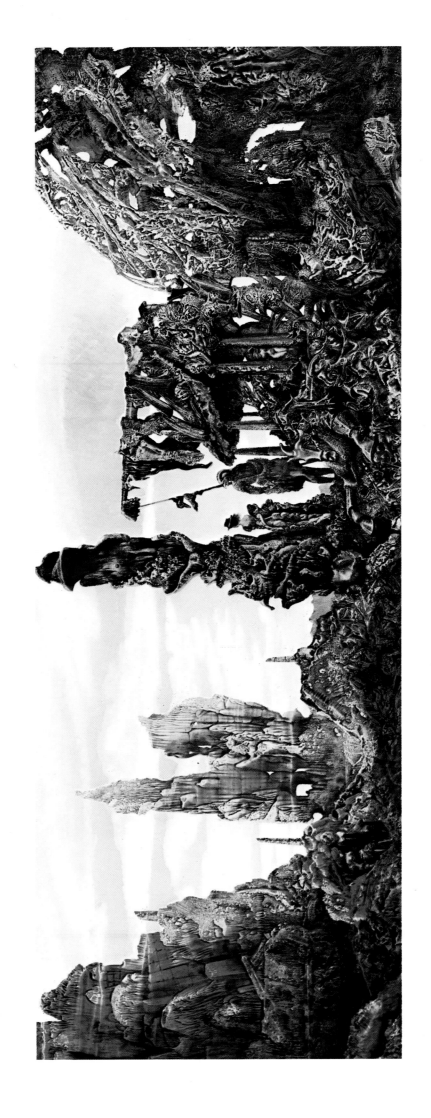

1943. Oil on canvas, 152 x 203 cm. New York, Acquavella Galleries

As if to celebrate his arrival in the United States, this is painting in the guise of the TV dinner, a visual version of Ernst's mythical biography: this time it is a record of his painterly production juxtaposed to intimations of his future course. The presentation, as though it were a panelled altarpiece, is echoed in the title's ecclesiastical air. It comprises a catalogue of techniques divided into 52 panels, Ernst's age at the time. Werner Spies notes that it is rather like a painted version of Duchamp's *Boîte en Valise*, in which compartments contain miniature versions of the artist's past work.

Some panels contain a reprise of the forest and jungle pictures, of decalcomania, paintings of the cosmos, imprisoned birds, all strictly regulated by blank and patterned panels, and set off by precise tools. Two panels show the Eiffel Tower and the Empire State Building, with reference to the artist's emigration. Some panels reprise *Caesar's Palette*, one of the frottages of the *Histoire Naturelle*. In *Caesar's Palette* Ernst had shown a leaf represented in a naturalistic style paired with a blank, cut-out leaf shape. The two obviously posit some relation: of object to sign or perhaps of sign to representation. Signification and reproduction are related since both involve repetition and variation.

Ernst's changing relation to geometry, once taboo, is also explored here. The anthropomorphic compass at the top of the piece seems to signal a humanization of the geometric and the rational. Even the signature is constructed from compasses. Ernst was to develop this work with geometrical form, often as a counterpoint to less ordered passages of painting.

Breakfast on the Grass

1944. Oil on canvas, 68 x 150 cm. New York, Private Collection

In 1935-6 Ernst made another work of this name which makes more direct reference to the famous work by the French artist, Edouard Manet: this represented hybrid creatures in a landscape. The French title of the version illustrated, as seen in the inscription, is rather curious: *'Le Déjeuner sur l'Herbre'*. 'Herbre' is a mixture of words in the manner of the poet and playwright Alfred Jarry, who infamously used the word 'merdre' to open his play, *Ubu Roi*. There may be some play on the verb *'herber'*, which means to bleach something, usually linen, on the grass, and thus bears some relation to the subject of the picture, although the point of such a pun is very obscure.

On one level this picture presents the remains of a picnic, with fruit, fish and abandoned bottle. On another, it is an image of a corrupt and decaying nature and of the violence inherent in consumption. It has also been seen as an image of a poisoned paradise. All these interpretations are distanced by Ernst's emphatic juxtaposition of word and image, for the painting is deliberately presented with its title panel, over which a stem and a leaf protrude. The position of the decalcomania landscape and the sky beyond also makes no logical sense, suggesting that while Ernst may be presenting the viewer with an image of horror, it is not one which allows us to suspend our disbelief.

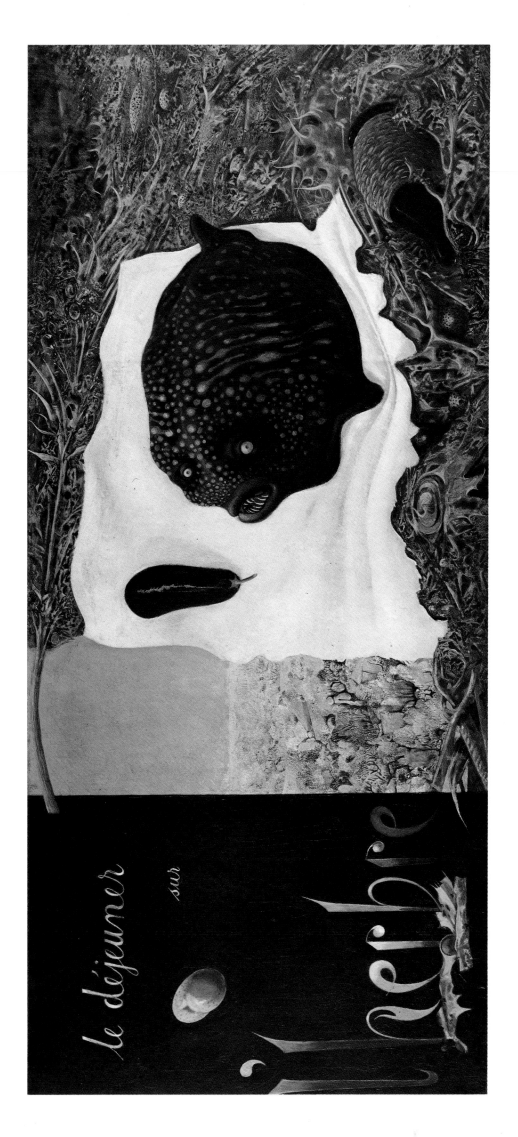

The Temptation of St Antony

1945. Oil on canvas, 108 x 128 cm. Duisburg, Wilhelm Lehmbruck Museum

While this picture appears similar to the decalcomania works in its feeling and iconography, the technique is actually used little here, most of the work being painted traditionally. It was made for a competition (in which Dalí, Leonora Carrington, Paul Delvaux, Stanley Spencer and Dorothea Tanning also competed) for a painting to appear in a film version of Guy de Maupassant's story, *Bel Ami*. The jury which awarded the prize to Ernst comprised Alfred Barr, Sidney Janis and Marcel Duchamp.

The Temptation of Saint Antony evokes the fifteenth-century German artist Matthias Grünewald's treatment of the same theme in the Isenheim altarpiece, where similar plant-animal metamorphoses occur. The writings of Isidore Ducasse, the so-called Comte de Lautréamont, which stressed the violence and the lawlessness of nature, may also have provided inspiration. It has been claimed that the painting also refers to the theme of sacred and profane love, indicated by the women in the background of the work, one apparently headless and striking a wanton pose, the other literally elevated on a pole. The face in the block at the centre of the painting, with one eye open, the other closed, reappears in *He Does Not See, He Sees* (Plate 40). This face is also reflected in one of the monsters which occupies the space between the saint's legs.

Ernst wrote in the catalogue to the competition: 'Shrieking for help and light across the stagnant water of his dark, sick mind, St Antony receives as an answer the echo of his fear: the laughter of the monsters created by his visions.' It is the mind of the saint which produces the hideous creatures which torment him. In contrast to Grünewald's depiction, the body of the saint is placed in a highly undignified and unstable position, his head tilted back, his mouth open, his orifices invaded by diverse creatures. This painting was made at the end of the Second World War, and this timing is surely significant to the theme of the production of monsters through myth and fantasy which, having become concrete, tear apart the body. In relation to Surrealism, Ernst may have been reminded of Breton's description of randomly shooting in a crowded street as a Surrealist act, or the declaration, *'Permettez'*, which expressed the hope that a statue of the poet Arthur Rimbaud, erected in his home town of Charleville, would be melted down into shells with which the place would be bombarded.

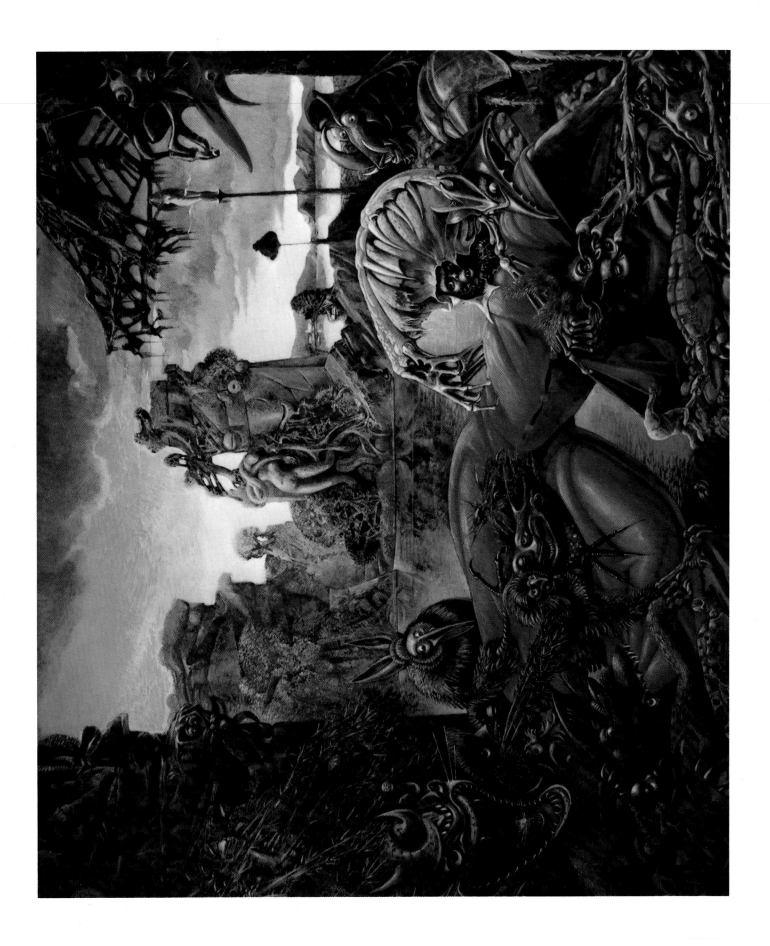

He Does Not See, He Sees

1947. Oil on canvas, 76 x 76 cm. Private Collection

Billed as a new version of the *Blind Swimmer* (Plate 27), this diagonal work shows a face (already seen in *The Temptation of Saint Antony*), with the title written in French along either side of it. One eye is closed and the other opened, illustrating the title. Interpenetrating areas suggest a vision which transcends conventional sight, perhaps in a four-dimensional fusing of separate planes. It has already been noted that blindness in Surrealism was used as a metaphor for progressing beyond conventional vision. Although this is supposedly a blind swimmer, the presence of water is barely felt, although it might be represented by the line at the bottom of the picture; one critic claims that the face is wearing goggles.

There is generally considered to have been a marked decline in Surrealist painting in general after the Second World War, and this falling off certainly appears to have affected Ernst. It was as though the fate of Futurism, whose fantasies of mechanical warfare were trumped by the reality of the First World War, was replayed with Surrealism and the Second World War, as if everything that these artists had imagined and more had become reality. For a while Ernst faced this realization in the decalcomania paintings, but then had to solve the problem of what possible directions were open next. He was to turn increasingly to themes of natural harmony, and to an obsession with the internal references of the iconography of his own *oeuvre*. This latter construction, designed as if for the employment of art historians, was a way of imbuing a private and essentially arbitrary iconography with a weight of significance through repetition in different contexts.

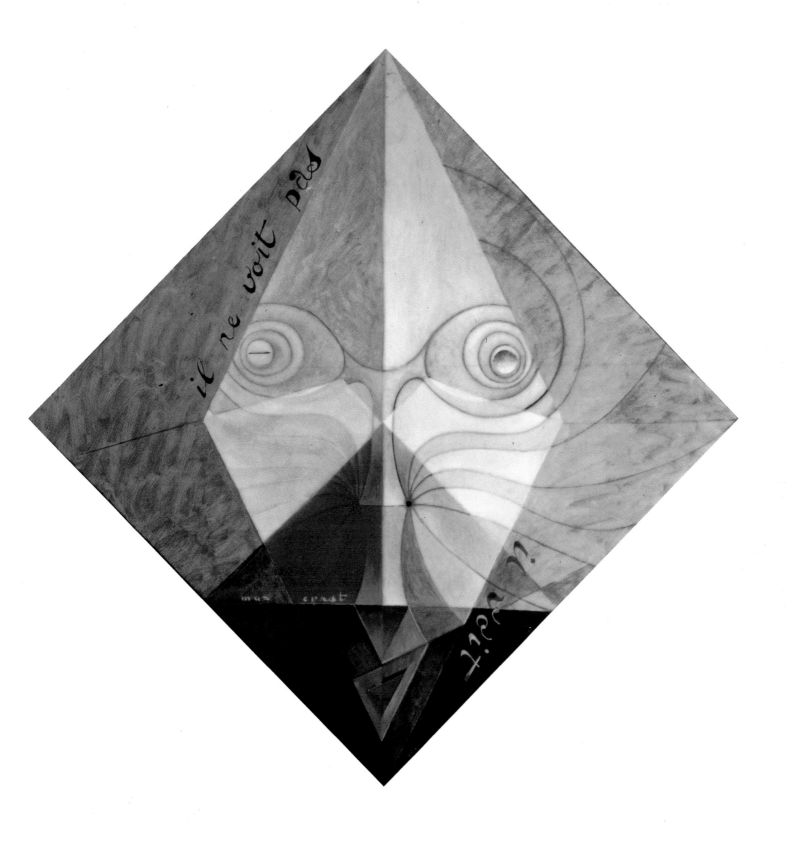

The King Playing with the Queen

1944. Bronze, 97.9 cm high. New York, Museum of Modern Art (gift of D. and J. Menil)

This was Ernst's first sculpture in ten years, being one of a batch he made in the summer of 1944 on Long Island; even this was not cast until a decade after the plaster was made. Although such a work was made by casting and assembling a variety of objects, often found (like household containers), when the piece was cast in bronze it lost all sense of heterogeneity: in this way, the work became the sculptural equivalent of the collage paintings.

The king has a bull's head, reminiscent of the dominant figure in *One Night of Love*, and again themes of sexual dominance and manipulation may be present. To this Ernst has added very apparent references to non-European art. In addition, the references to chess in the work continue the artistic dialogue with Duchamp in which Ernst was engaged. The sculpture also bears a marked similarity to earlier works by Alberto Giacometti, particularly to his table pieces of the 1930s. The clean, hollowed-out form of the King's torso perhaps relates the sculpture to earlier paintings such as *Old Man, Woman and Flower* (Plate 10), where the body of the flower appears as a husk.

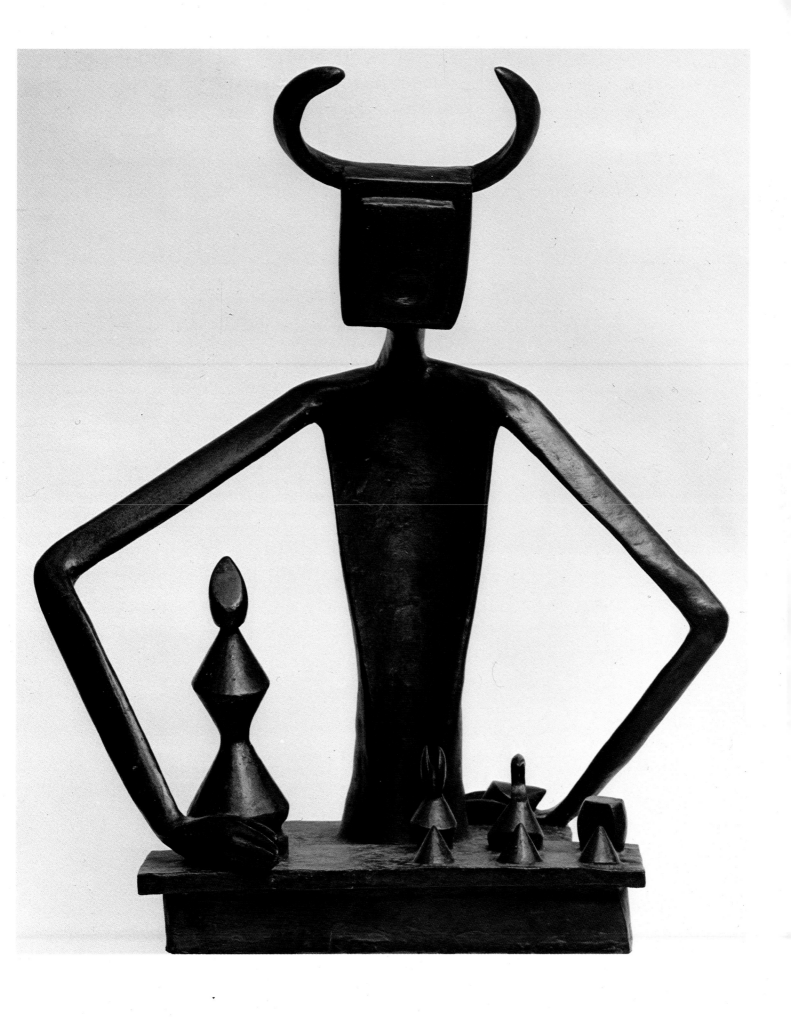

Young Man Intrigued by the Flight of a Non-Euclidean Fly

1942-7. Oil and varnish on canvas, 82 x 66 cm. Switzerland, Private Collection

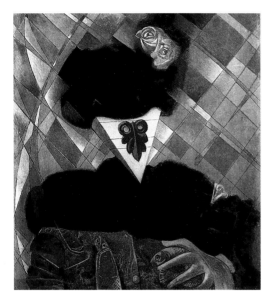

Fig. 32
Euclid
1945. Oil on canvas,
64 x 59 cm. Houston,
Menil Foundation

The curved lines and splotches which erratically orbit a central point in this picture were made by using a can with a hole in the bottom, filled with paint and swung from a string above the canvas. The can could be guided but not fully controlled by the artist. Ernst claimed that after this process was complete the subject was arrived at by free association. While the procedures of Surrealism have been followed (the mix of control and automatism) the end result is jokey rather than revelatory. For Werner Spies the web formed by such a method brings out associations with the mythological figure of Ariadne, and thus with the story of the Minotaur and the labyrinth. Jackson Pollock saw this work in 1942 and was much interested by the method, though of course his drip paintings were very different in scale, feeling and execution.

Ernst was very interested by non-Euclidean geometry, which is capable of describing other mathematically constructed dimensions beyond the three spatial dimensions in which we exist, and which was the basis for the scientific revolutions of the first decade of the twentieth century. We might read this picture straightforwardly as a representation of an angular and rational young man worried by the apparently ungovernable movements of the fly. Yet there is a typical blurring of identities in this work, for the head with its compound eyes is more like that of a fly than a man. The painting is related to *Euclid* (Fig. 32) which has a similarly triangular head and naturally, given the subject, a more ordered background formed by a complex linear grid. This work is reminiscent of Guiseppe Archimboldo's fantastic composite portraits from the sixteenth century. While it is dominated by geometry, this is played off against a passage of grattage used in the garment draped over the figure's arm.

The *Young Man* was originally called *Abstract Art, Concrete Art*, an intriguing earlier title. In post-War Paris the artistic community was involved in a debate between opposing abstract and concrete tendencies, the point of dispute being whether painting should be autonomous from reality or abstracted from it. Ernst's friend Jean Arp was involved with the movement called Concrete Art, and an important Concrete Art exhibition was held in Paris in 1945. The different styles within this picture seem to re-enact the conflicts which took place between abstract artists in the post-War years, including the tussles between spontaneous tachists and Neo-Platonic geometricians.

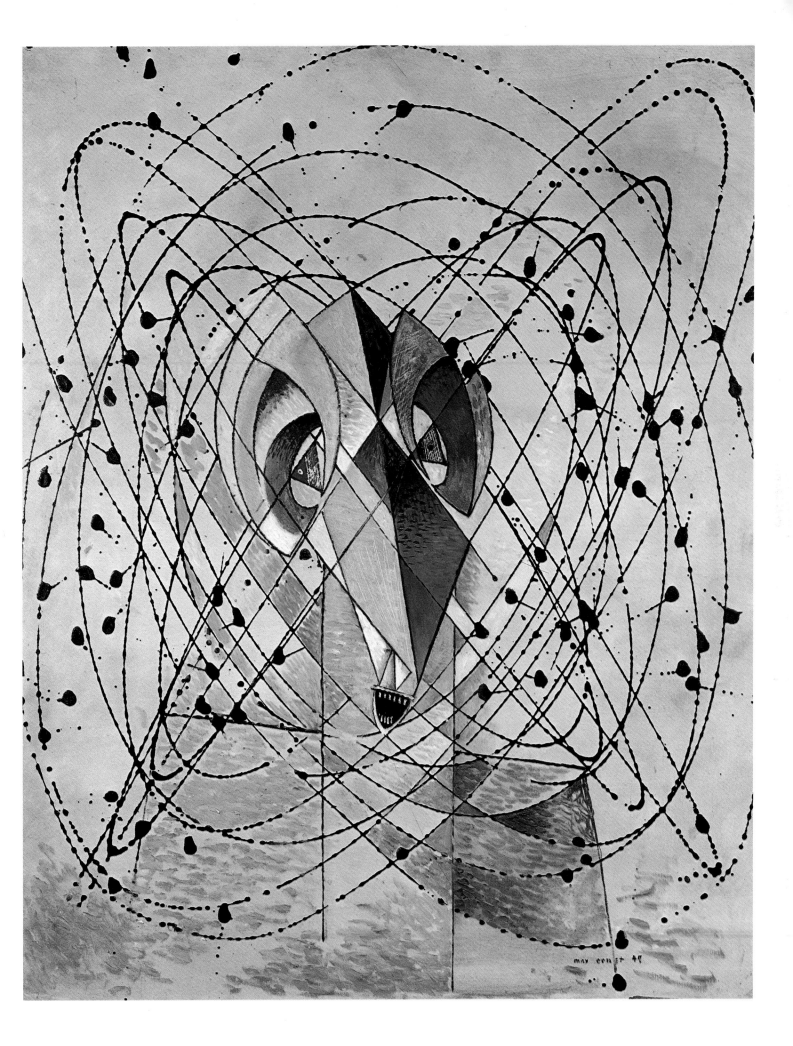

After Me, Sleep

1958. Oil on canvas, 130 x 89 cm. Paris, Centre Georges Pompidou,
Musée National d'Art Moderne

After Me, Sleep is an elegy for Paul Eluard, who died in 1952. The motif is
based on a design Ernst made in around 1929 as an ex libris for the poet's
library. While this may be compared with the bird monuments (Plates 16,
17 and 20), the work seems a good deal more earnest than that of the
1920s.

After Me, Sleep exemplifies what had by now become Ernst's overriding
concern with the surface of painting: compared to earlier pieces, and espe-
cially to the dry collage paintings of the early 1920s, this is a lush, beauti-
ful work. It is ironic that this undoubted improvement in technical ability
is often considered to be matched by a decline in the actual interest of the
works themselves. Ernst's new formal and iconographic seriousness was
symptomatic of his break with Surrealism, caused most of all by his receiv-
ing the prize at the 1954 Venice Biennale, what Breton later called Ernst's
'Venetian consecration', which was 'a renunciation of that which his
Surrealist friends considered to be infinitely more important than his
eminent 'pictorial' position: that is, his revolutionary moral position ...'

Such works do nevertheless continue earlier interests. As early as 1934,
in the book *Was Ist Surrealismus?*, Ernst has written that the Surrealists did
not just paint dreams which would amount to 'naive naturalism', nor build
'little worlds' from dream elements, which would be escapist, but rather,
'... they move freely, daringly and naturally on the physically and mentally
quite real ('Surreal'), if still largely undefined, frontier between interior
and exterior world, registering what they see and experience there, and
intervening where their revolutionary instincts suggest.' Confirmation of
Surrealist theories was apparently to be found in the erosion of the bound-
aries between subject and object in the physical laws outlined by
quantum theory, and this provided Ernst with a natural basis for his con-
tinuing treatment of old concerns.

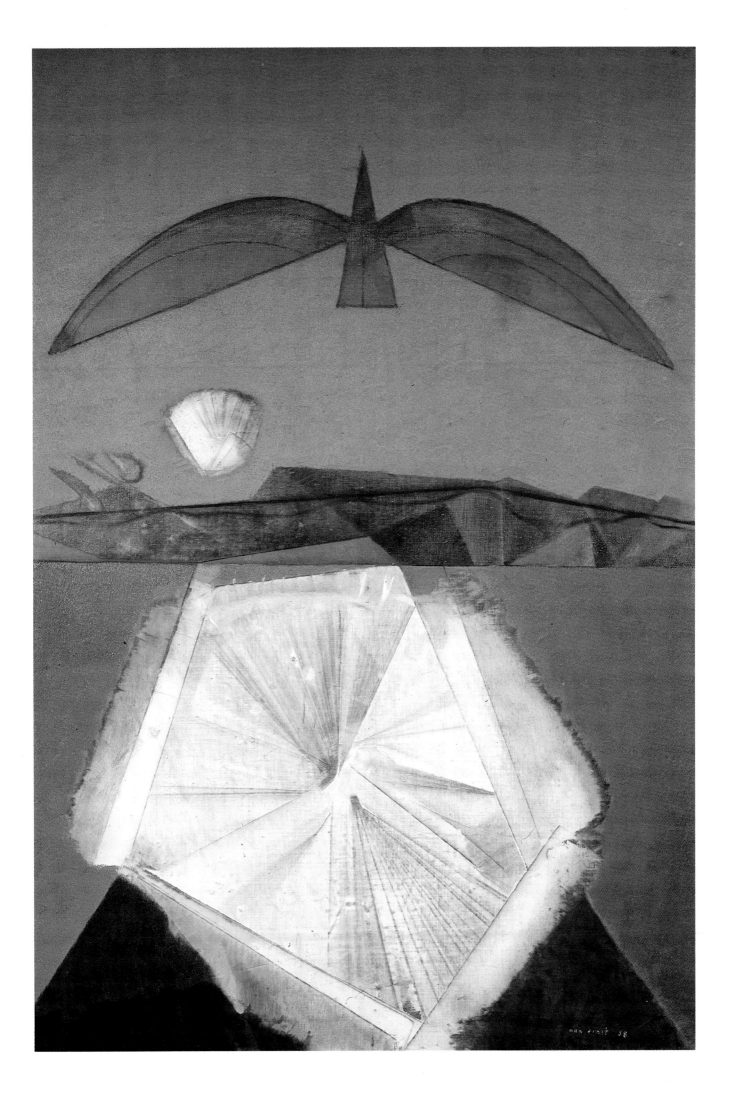

Old Father Rhine

1953. Oil on canvas, 114 x 146 cm. Basle, Kunstmuseum

Thin layers of glazed paint create a transparent world of overlapping realities, in which identities are merged and lost. John Russell has interpreted this as standing in for the interpenetration of the conscious by the unconscious. The central meander in the river forms a head, harking back to ancient personifications of rivers. The 'head' contains linear bird forms. Traces of human presence are absent: this is a work about nature, and possibly about the reading of signs within its forms.

Such works are decidedly odd in the context of Ernst's past production. If we accept that the concerns of Surrealism were superseded by those of the Second World War, it could be suggested that Ernst sought refuge, no longer in revolution, but in nature. A sublime harmony, grasped almost intellectually and held constantly in view, rather than glimpsed in irrational extremes, is posited, something which nevertheless escapes intellectual understanding.

In the frottages of the *Histoire Naturelle*, and the associated grattages, Ernst's Lamarckianism remained undefined: he was concerned with process, rupturing and flowing. Later works acquired a certain fixity, as in *Old Father Rhine*, where interpenetration serves the purpose of integrating, rather than randomly and crudely shackling together, diverse natural elements into a pantheistic whole.

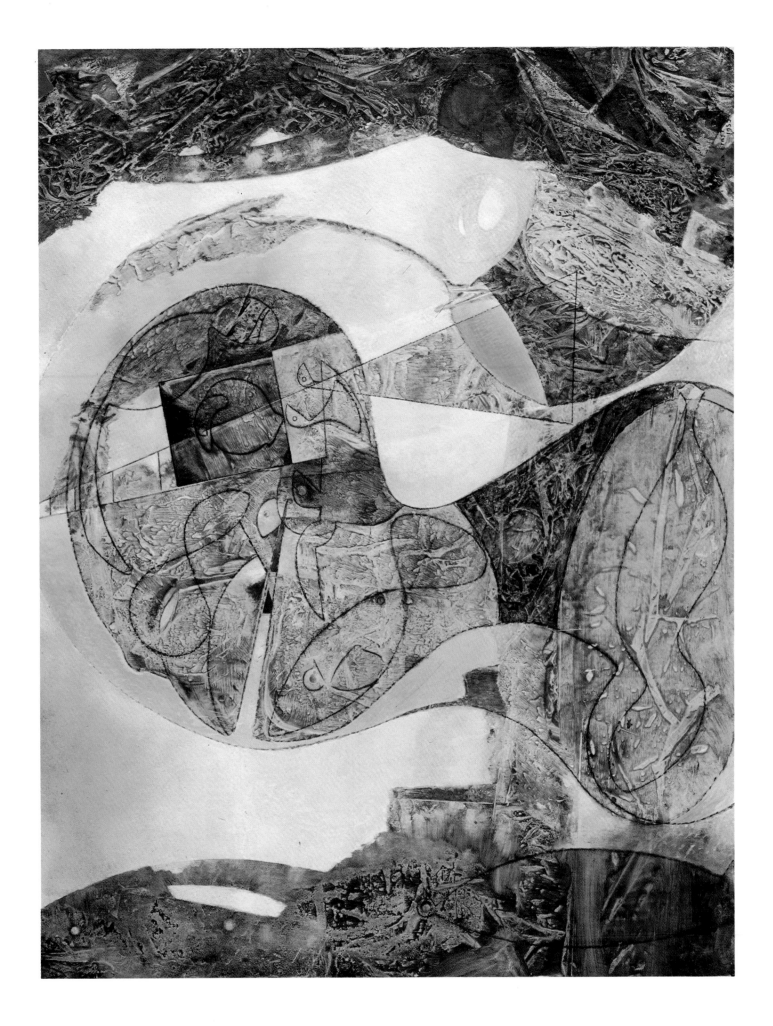

Coloradeau of Medusa

1953. Oil on canvas, 73 x 92 cm. Paris, Private Collection

This painting contains an apparent reference to Théodore Géricault's *The Raft of the Medusa* (1817-19). *'Radeau'* is the French word for a raft. If this association is valid, the old Surrealist themes of the shipwreck and maritime journey – of the ship of consciousness being lost on the high seas of the id, and of voyages of discovery in the depths – become relevant. The painting is probably a reference to the trip that Ernst, Tanning and others made down the Colorado River in 1948, when their party was mistakenly reported as lost.

It is unclear whether the scene is set above or below the surface of the water, or both. In the lower part of the painting, a fish and a sphinx-like figure make contact. The rubbing away of the paint has yielded a rough, consistent surface which is combined with some decalcomania sections. Parts of this work almost seem to relate to colour field painting: the homogeneous surface fixes the work as a unity, in contrast to the radical diversity of collage and even frottage.

In the same year as the creation of this painting, Ernst wrote a poem obviously related to it, which appeared in his book *Sept Microbes*:

Coloradeau
La stupeur nous saisit devant tes odeurs
de bitume fourbe
de chocolat calcaire
de cruelles verdures
de linge mouillé de méduse
colorado
coloradeau de méduse

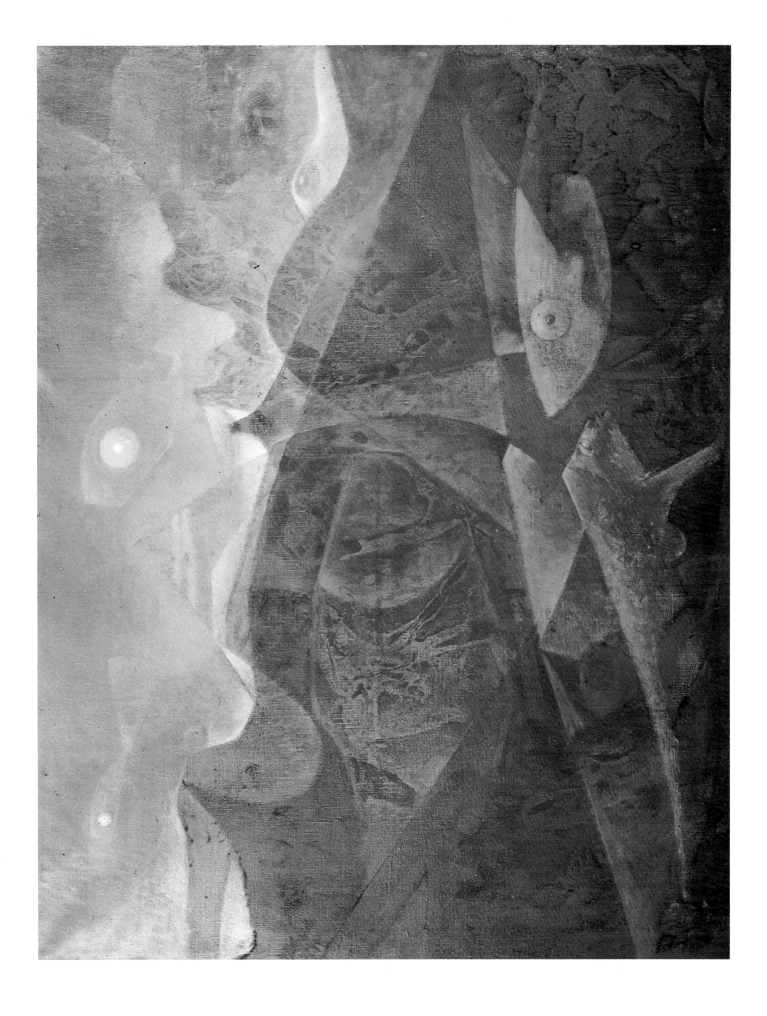

Almost-Dead Romanticism

1960. Oil on canvas, 32 x 23 cm. Milan, Private Collection

This work uses mixed methods of grattage and decalcomania. The title (in French, *Quasi-Feu le Romantisme*) is often considered ironic – but as with most of Ernst's irony, there is some serious point behind it. Surrealism, particularly in its post-Second World War phase, has sometimes been characterized as the fag-end of Romanticism, and Ernst, with his constant interest in Romantic icons (stars, forests, ruins, birds and monsters) could be used to support such an argument. In this subdued representation of the forest, there is a sense of mourning in the concentration on the leaf mould and the detritus of the forest floor. The oval disk at the top seems to be a diminishing light, and the painting as a whole seems to be poorly lit. Compared to the earlier forest paintings, the viewer of this small work is positioned inside the forest, with no apparent way out, rather than looking in from the outside on a menacing presence.

There is an apparent engagement of emotion and commitment in some of the later work which is in marked contrast to the detachment of Ernst's earlier pieces. The dryness and even the ineptitude of the collage paintings appeared to give them the status of non-intentional apparitions, of something stumbled across, rather than something presented as fine art. Ernst's interest in contemporary science and the inspiration he took from microphotography, combined with beautiful painted surfaces, removed this sense of distance and seemed to refer these late works back to an older world of talent and inspiration.

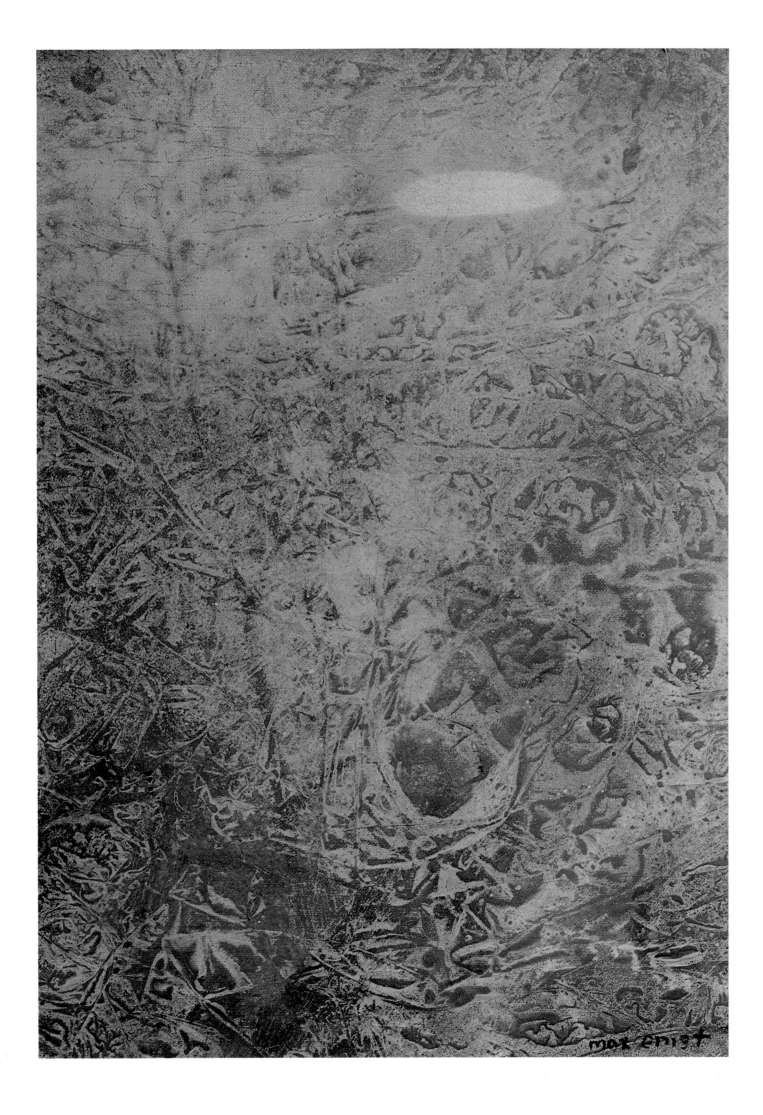

max ernst

1965. Oil on canvas, 115.8 x 88.7 cm. Paris, Centre Georges Pompidou, Musée National d'Art Moderne

Ernst employed a pictographic, 'secret' writing in illustrations to his 1964 book *Maximiliana ou l'exercise illégal de l'astronomie*, about Wilhelm Tempel, a nineteenth-century amateur astronomer whose discoveries were at the time repudiated by professionals. Elements in the picture and the title appear to refer to the same theme. This cryptic writing is reminiscent of that used by the Surrealist writer and painter, Henri Michaux, forming a very literal register of endless and indeterminate interpretation as in the pseudo-scientific systems of alchemy and psychoanalysis (Fig. 33). Here it simulates meaning, just as the collage paintings of the 1920s had done.

The work is divided by thin lines into discrete sections in which forms sometimes reflect each other, as though the viewer looked down into a complex series of mirrors. Pictographic representations of birds and people sit juxtaposed to the writing, spray-painted planetary forms and vague, indeterminate background shapes. There is a feeling that a number of planes are involved, as though the writing and drawings appear on the surface of panes of glass which are transparent or which partially reflect another aspect. Writing and representation can therefore be seen as forms which are inscribed over an indeterminate world, and which, despite their apparent clarity, are in fact as mysterious and unreadable as the things they are intended to reflect.

Fig. 33
Illustration from
'Maximiliana'
1964. Original collage in
Hamburg, Museum für
Kunst und Gewerbe

1962. Oil on canvas, 116.2 x 88.9 cm. Paris, Collection of Lois and Georges de Menil

This work was one of a series of planet and sun paintings made between 1960 and 1962, in which may be noted a certain loss of the overweening irony deployed in Ernst's earlier career. Many similar works of the period contain the same blue-yellow opposition of which Ernst had written in 1917. Often the opposition is between ground and sun and employs the usual reversal of common attributes, so that the sun appears dark and the earth light. Here a darker planet with a spray-painted aura floats above a much lighter ground, which seems to react to its presence, forming a bowl below it. The symbolism of the sphere is apparently meant to be taken seriously here. An alchemical motif is once again present, the marriage of the earth with the rays of the fertilizing sun.

How seriously this image of cosmic harmony should be taken is open to question: this work and Plate 47 may bear witness to a secret harmony of signs and the universe, of images and representation. Even frottage can be seen as a discovery about nature as well as about the mind. Such cosmic subjects interested Ernst throughout his career, and his art is heavily populated with planet and sun forms. Works from 1925 like *Mer et Soleil* (Fig. 6) are very close to this late piece: here too there appears a dark sun, coupled with a light one which also sports an eye. The alchemical and cosmic marriage of opposites was of course a theme of the painting *Men Shall Know Nothing of This* (Plate 12), but where that image was clearly distanced and ironic, there is nothing in *The Marriage of Heaven and Earth* to suggest that we should not read the image straightforwardly. While the irony of the earlier works, particularly those in the frottage technique, is sometimes overstated, it is also true that Ernst returned to an apparent belief in natural harmony, and the significance of colour and beauty.

CONSTABLE
John Sunderland

DEGAS
Keith Roberts

DUTCH
PAINTING
Christopher Brown

MAX ERNST
Ian Turpin

FRA ANGELICO
Christopher Lloyd

HOLBEIN
Helen Langdon

ITALIAN
RENAISSANCE
PAINTING
Keith Roberts

MAGRITTE
Richard Calvocoressi

MODIGLIANI
Douglas Hall

MUNCH
John Boulton Smith

PISSARRO
Christopher Lloyd

TOULOUSE-
LAUTREC
Edward Lucie-Smith

PHAIDON COLOUR LIBRARY

Titles in the series

BRUEGEL
Keith Roberts

CEZANNE
Catherine Dean

CONSTABLE
John Sunderland

DEGAS
Keith Roberts

DUTCH PAINTING
Christopher Brown

ERNST
Ian Turpin

FRA ANGELICO
Christopher Lloyd

GAUGUIN
Alan Bowness

HOLBEIN
Helen Langdon

ITALIAN RENAISSANCE PAINTING
Sara Elliott

JAPANESE COLOUR PRINTS
J. Hillier

KLEE
Douglas Hall

MAGRITTE
Richard Calvocoressi

MANET
John Richardson

MATISSE
Nicholas Watkins

MODIGLIANI
Douglas Hall

MONET
John House

MUNCH
John Boulton Smith

PICASSO
Roland Penrose

PISSARRO
Christopher Lloyd

THE PRE-RAPHAELITES
Andrea Rose

REMBRANDT
Michael Kitson

RENOIR
William Gaunt

SURREALIST PAINTING
Simon Wilson

TOULOUSE-LAUTREC
Edward Lucie-Smith

TURNER
William Gaunt

VAN GOGH
Wilhelm Uhde